Geometric Designs and Patterns Coloring Book
Volume 2

Over 50 designs to help relax and stay inspired

Gholamreza Zare & Pegah Malekpour Alamdari

This book belongs to:

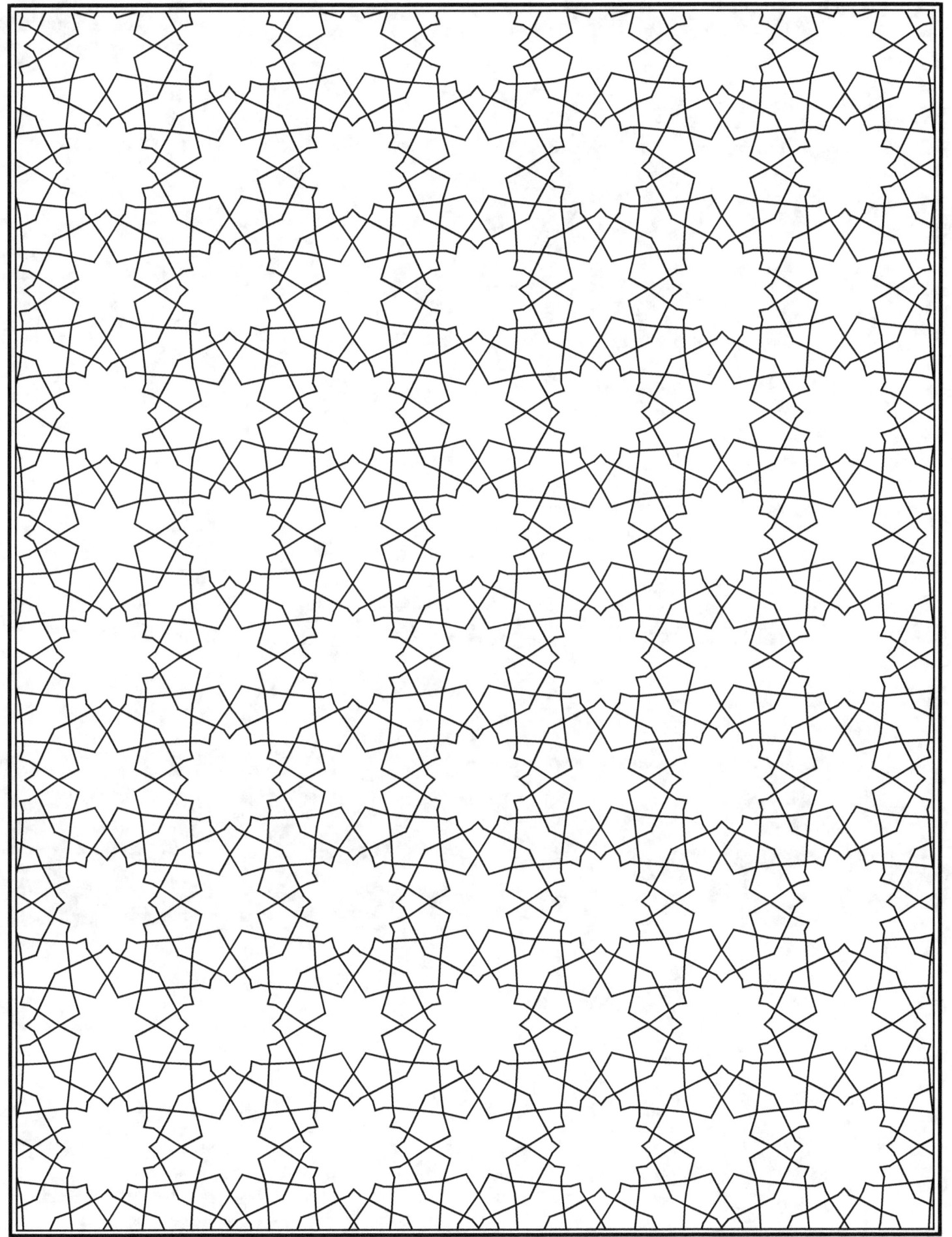

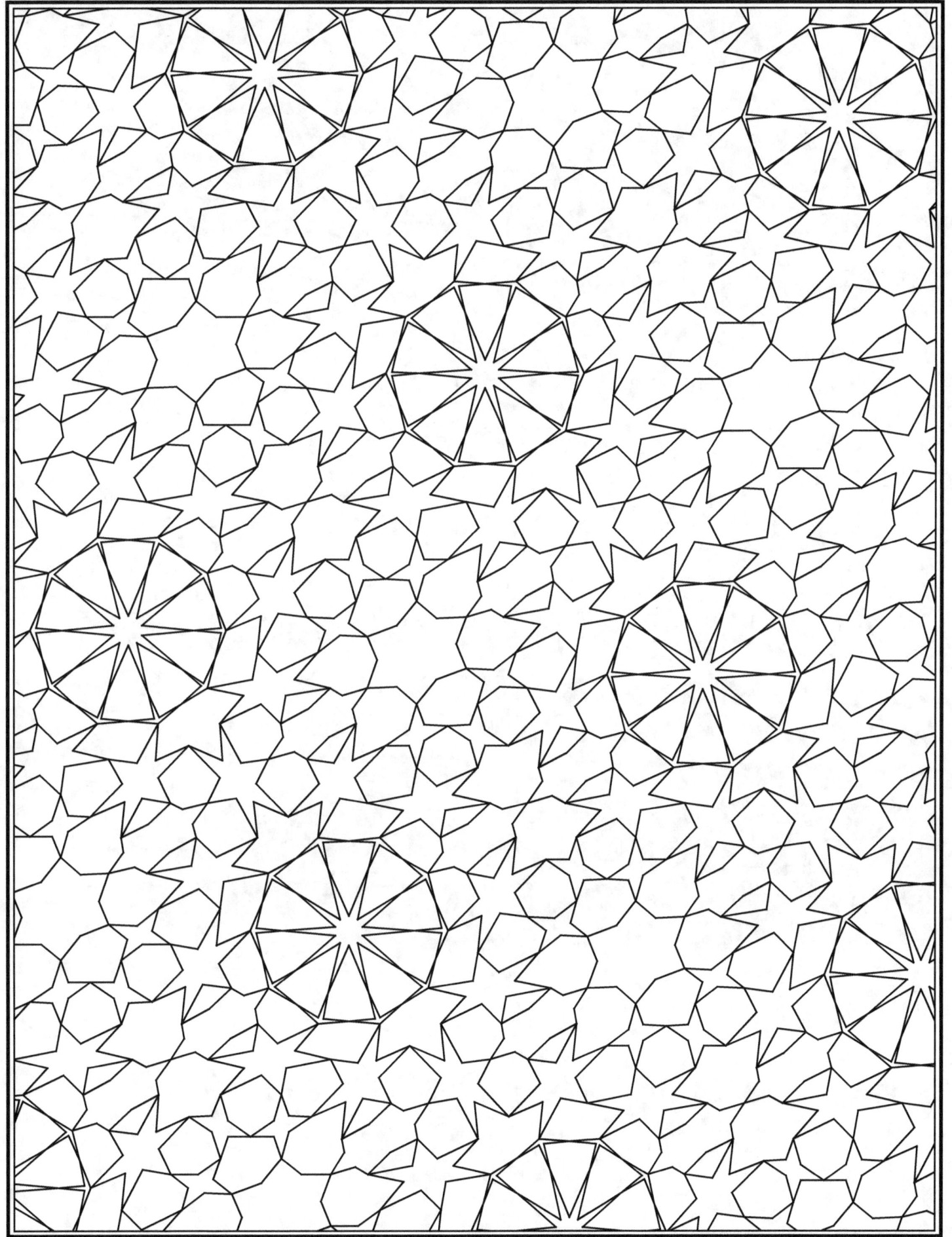

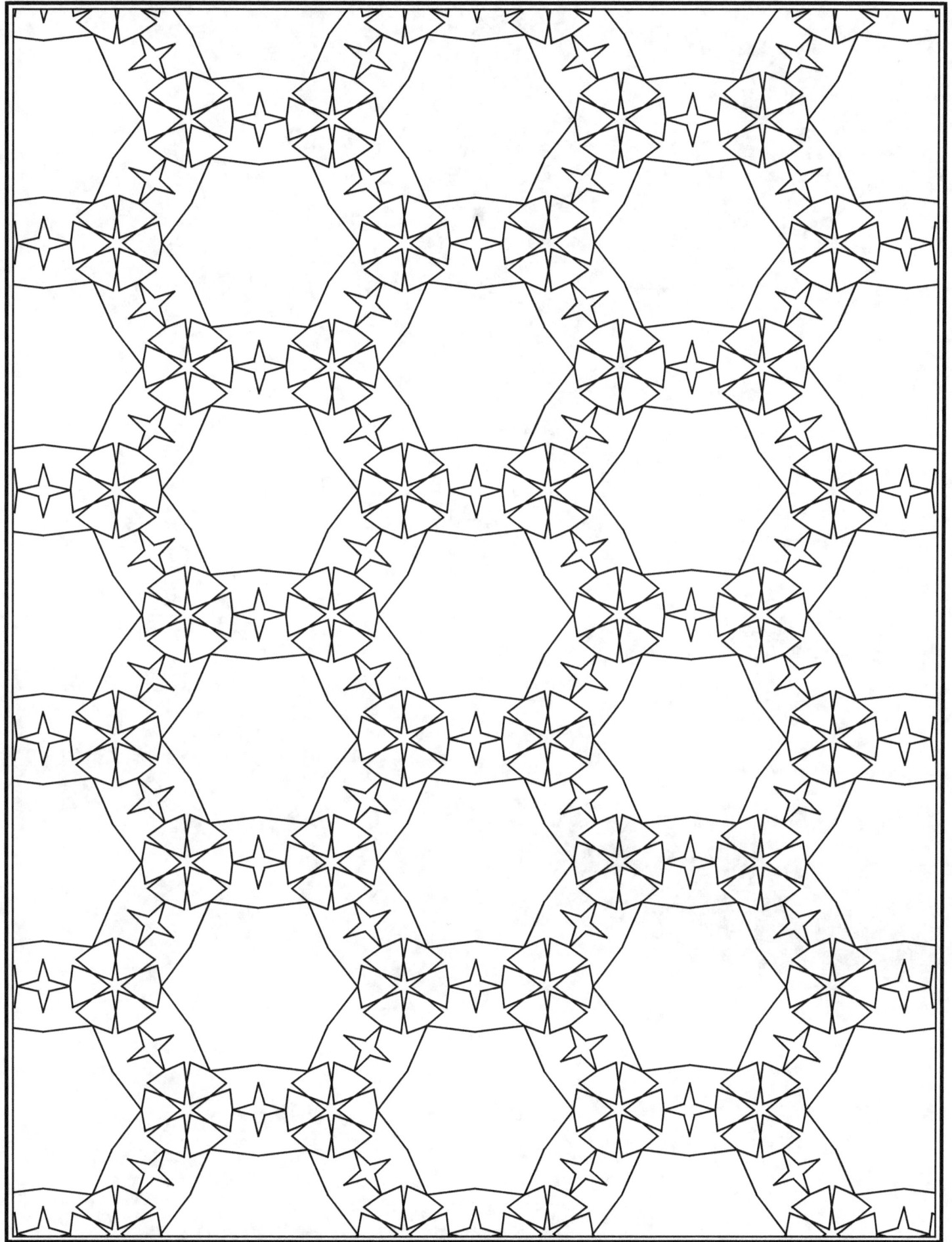

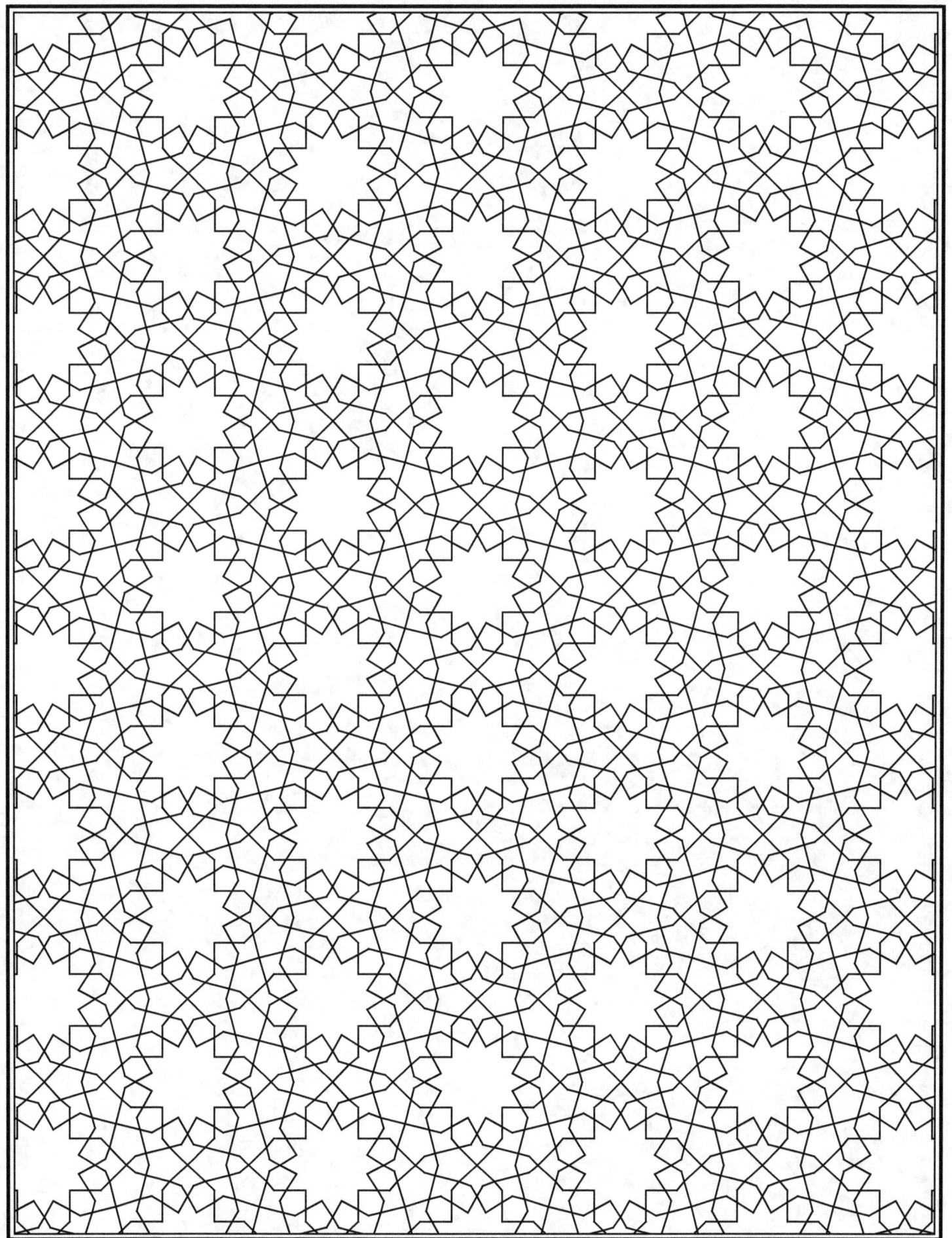

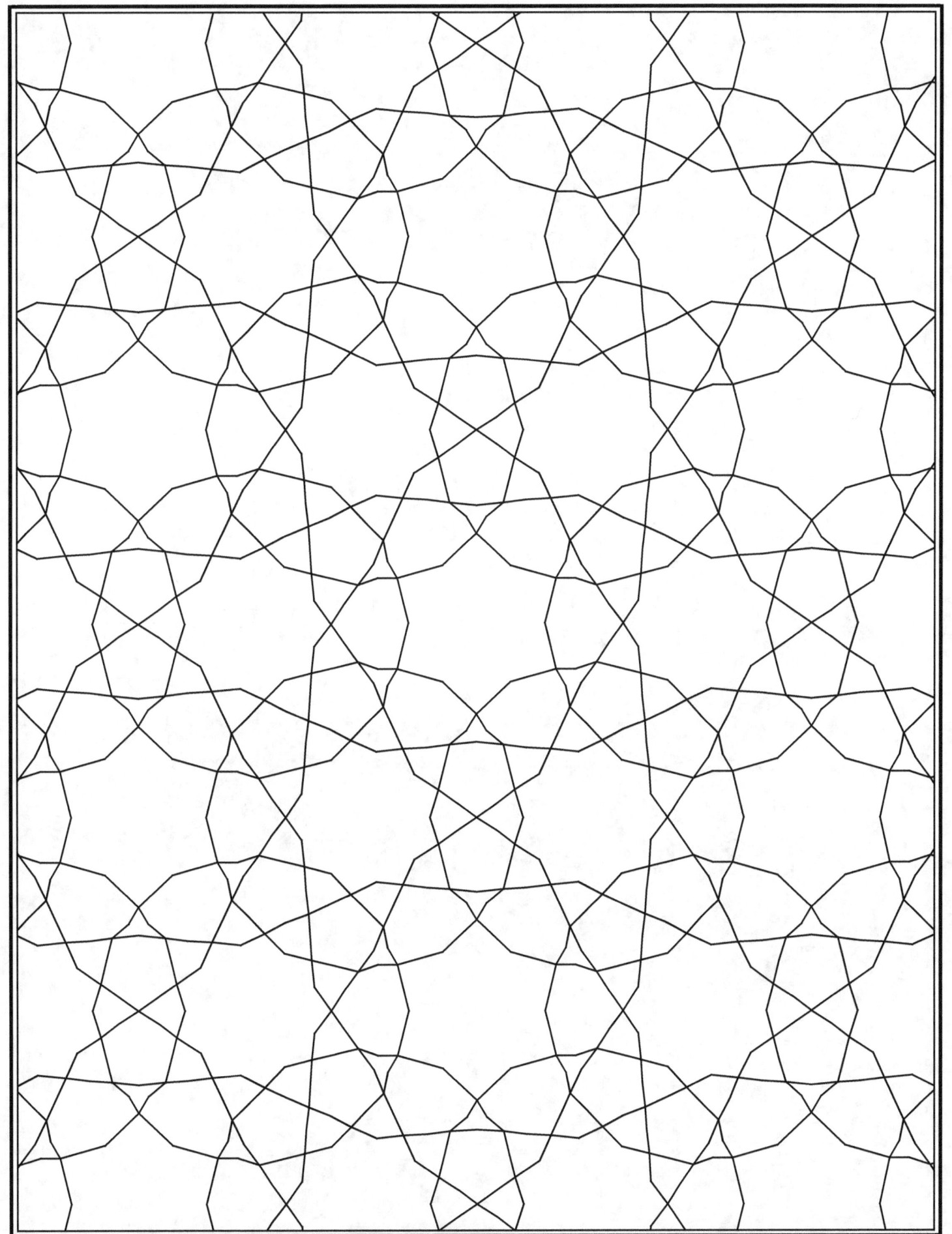

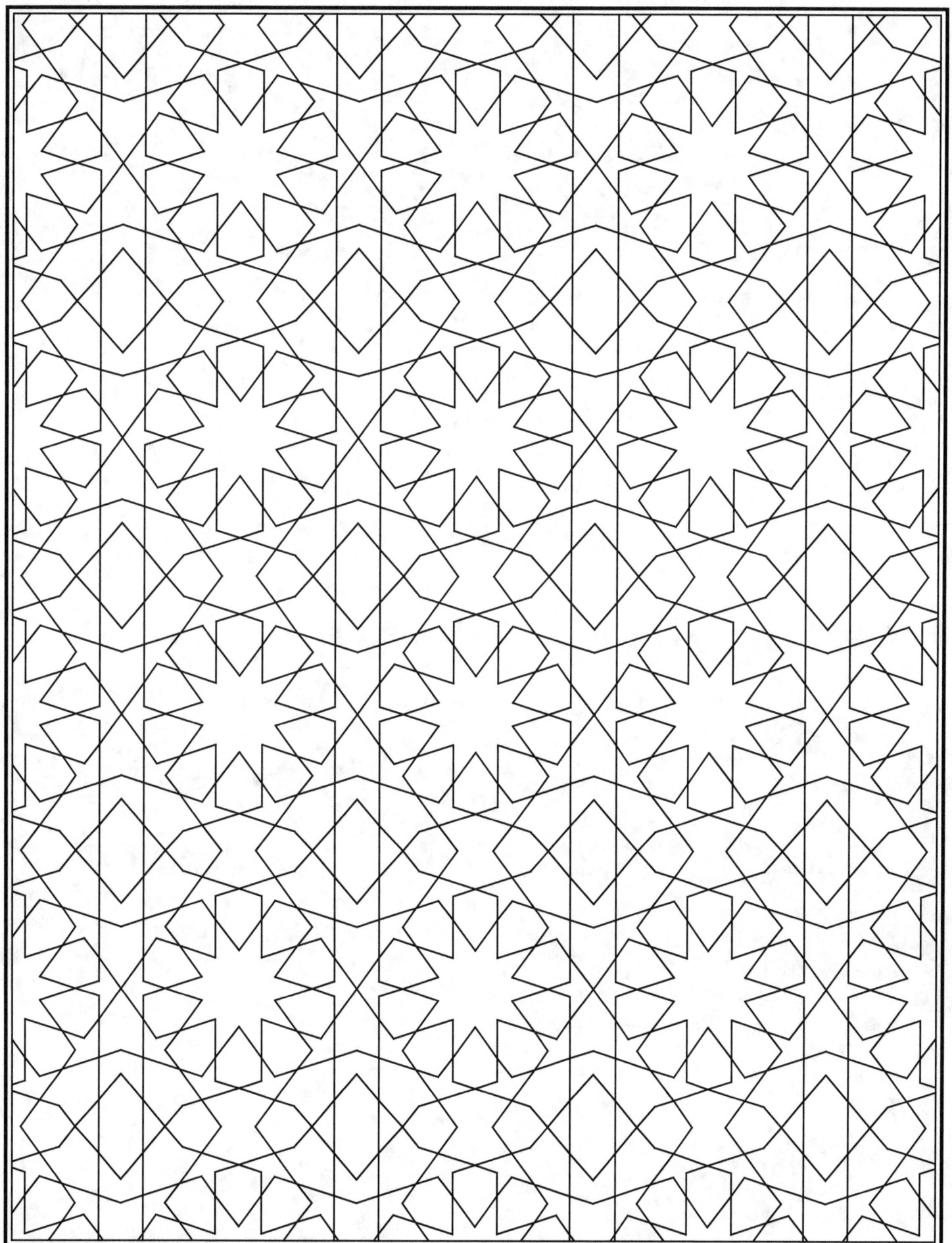

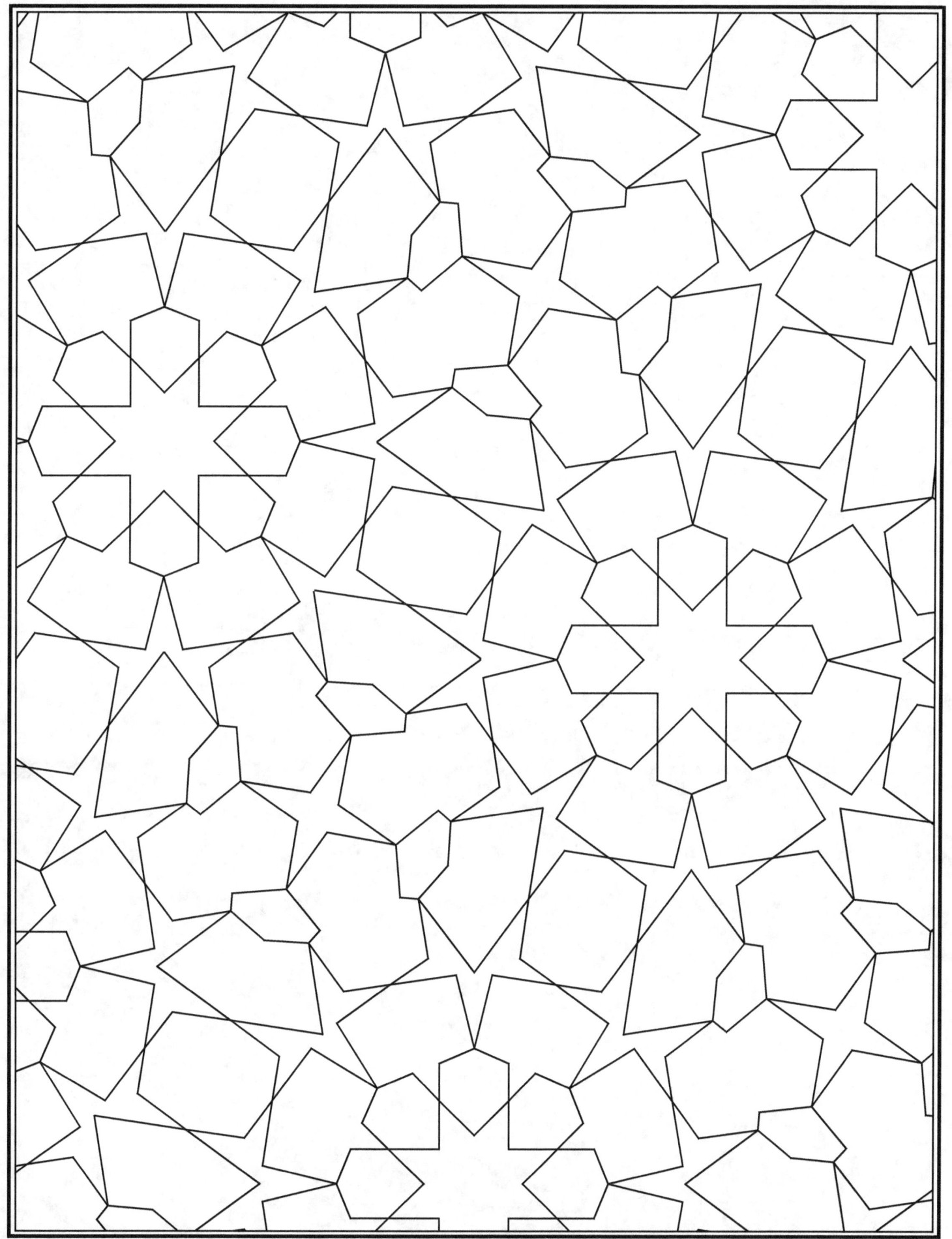

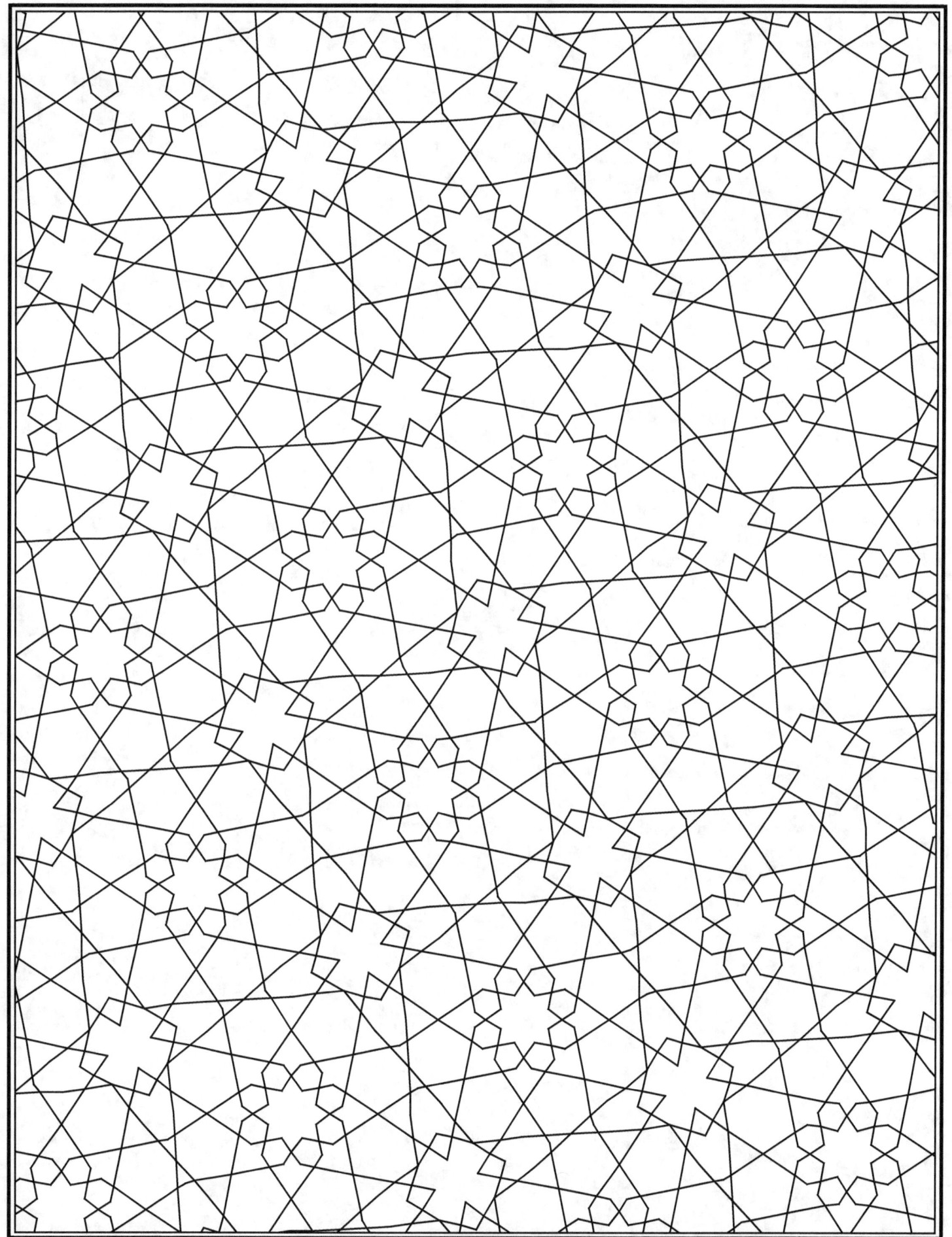

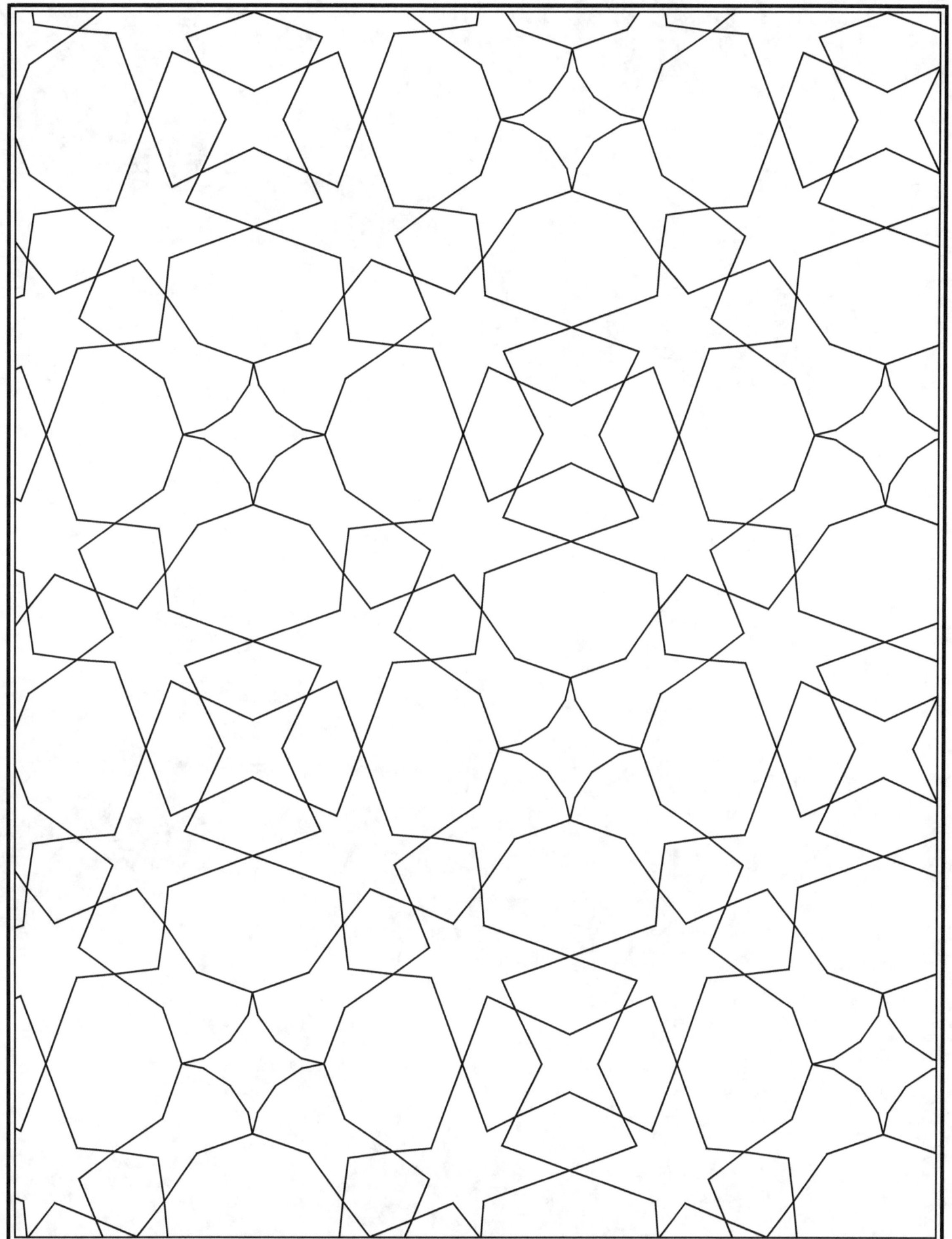

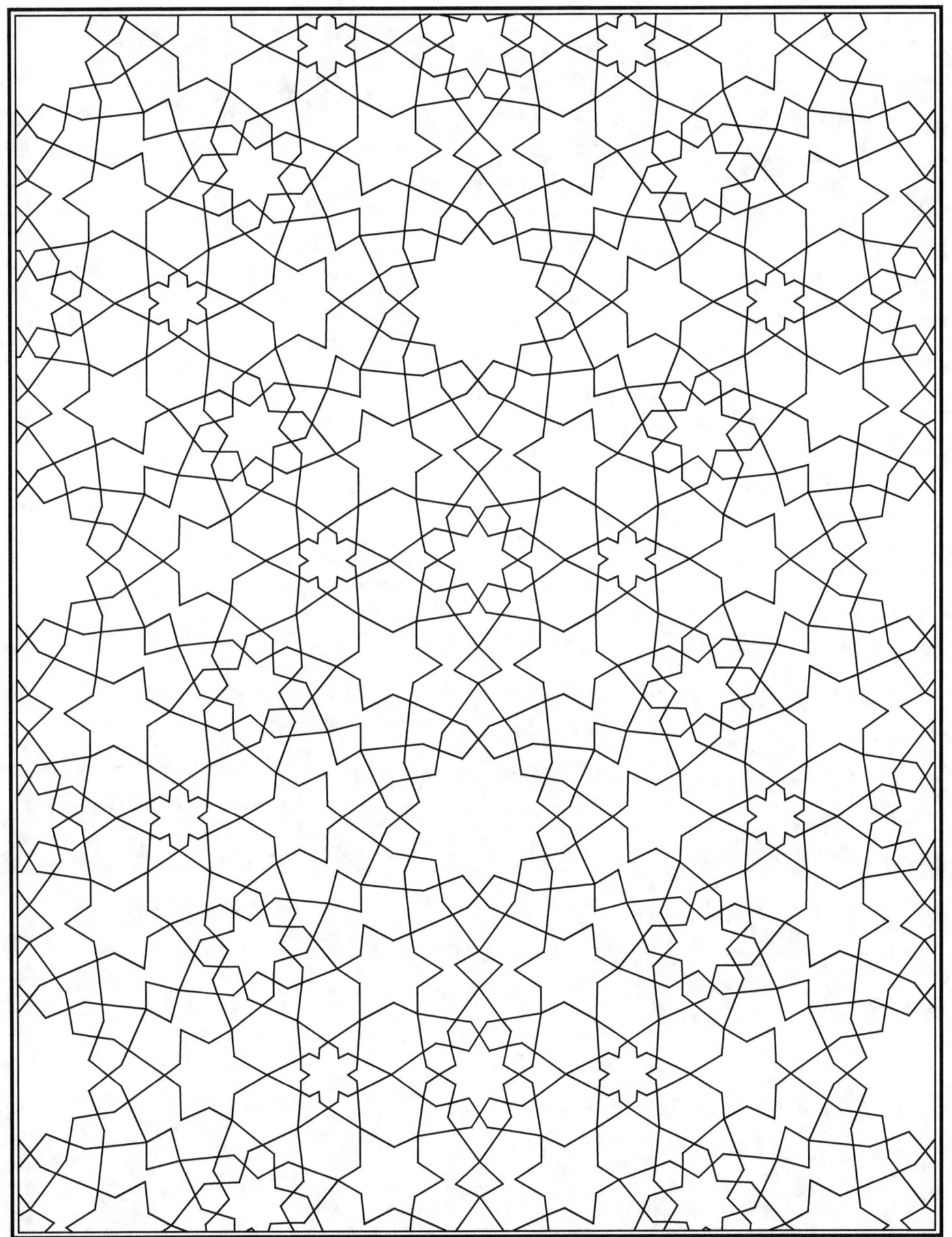

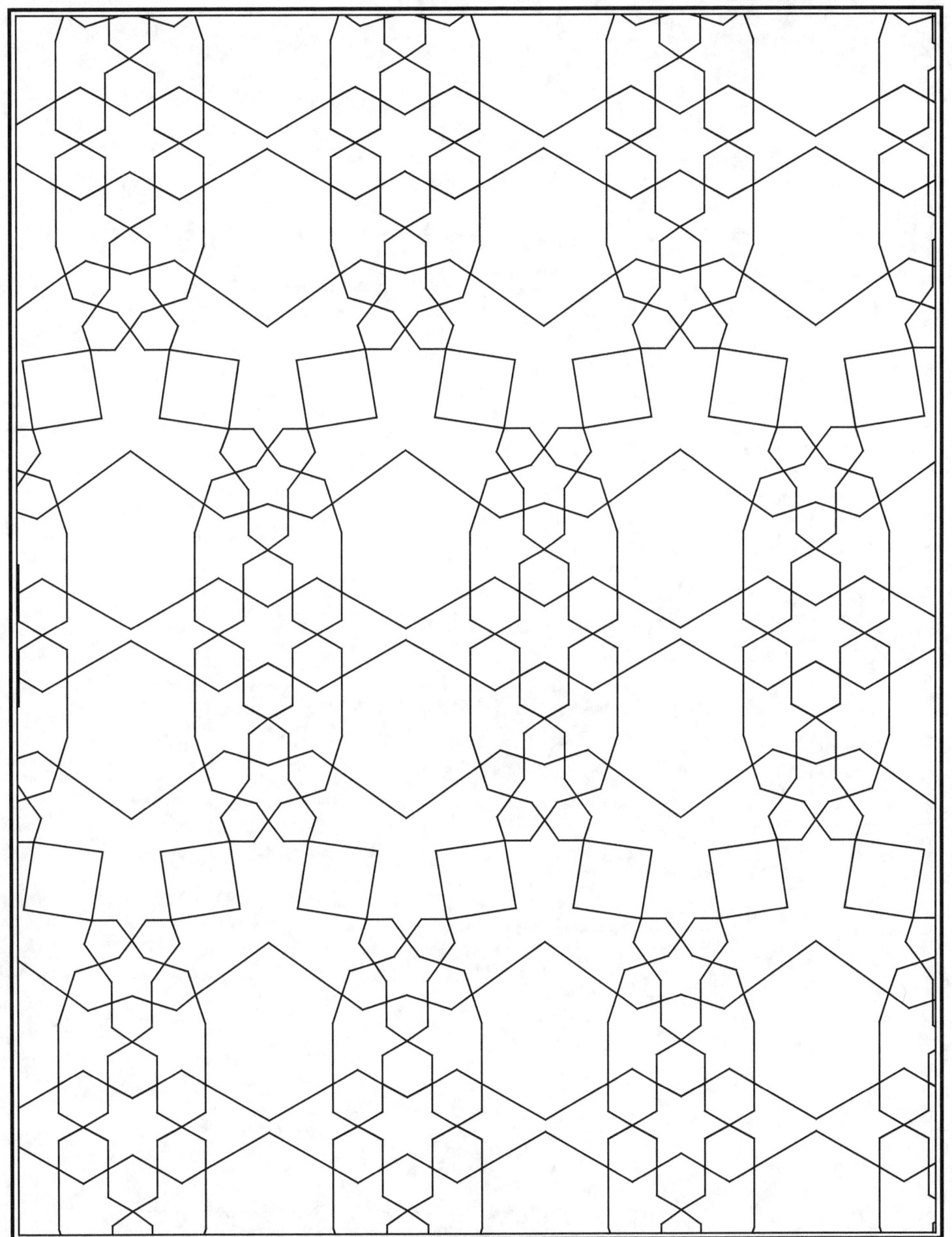

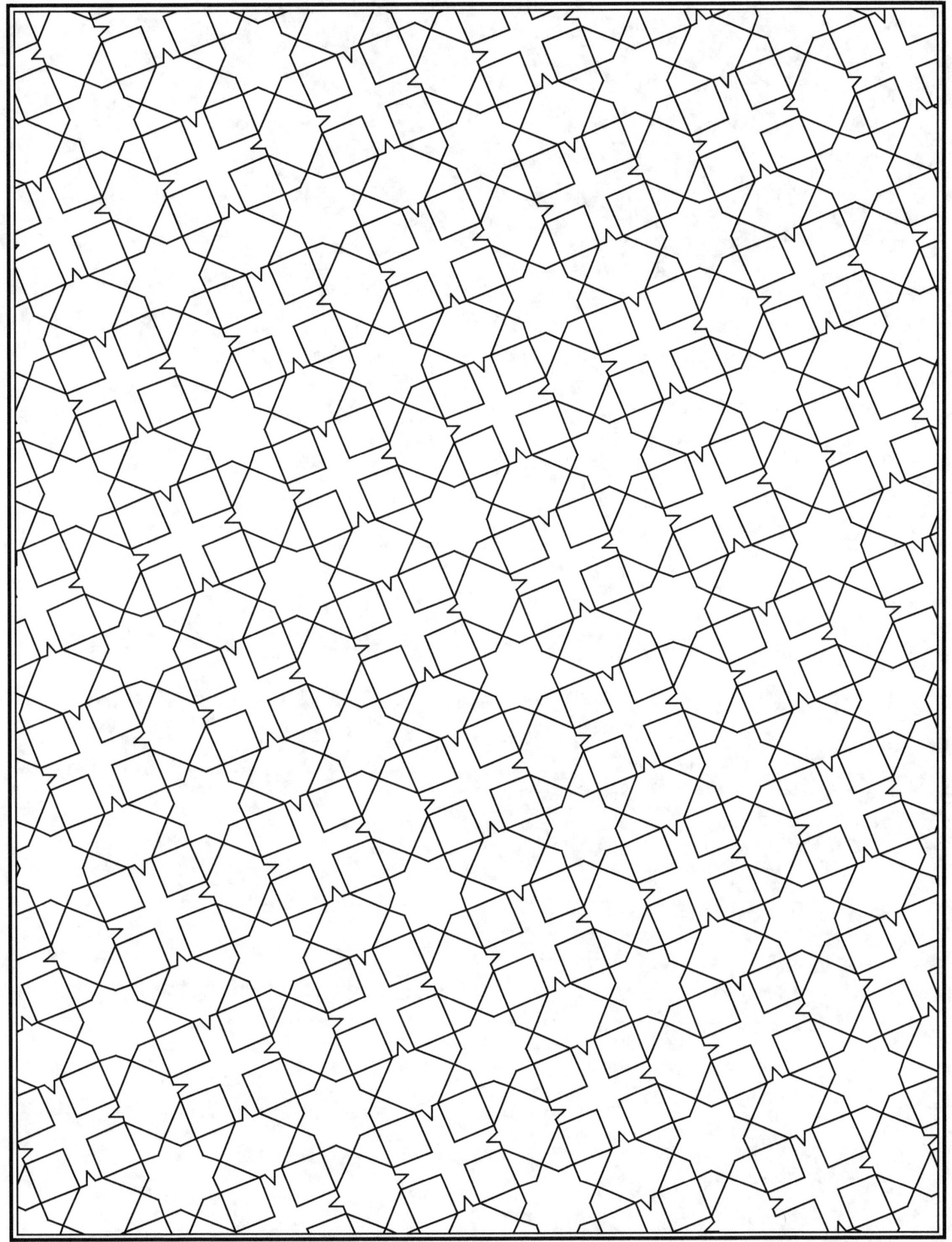

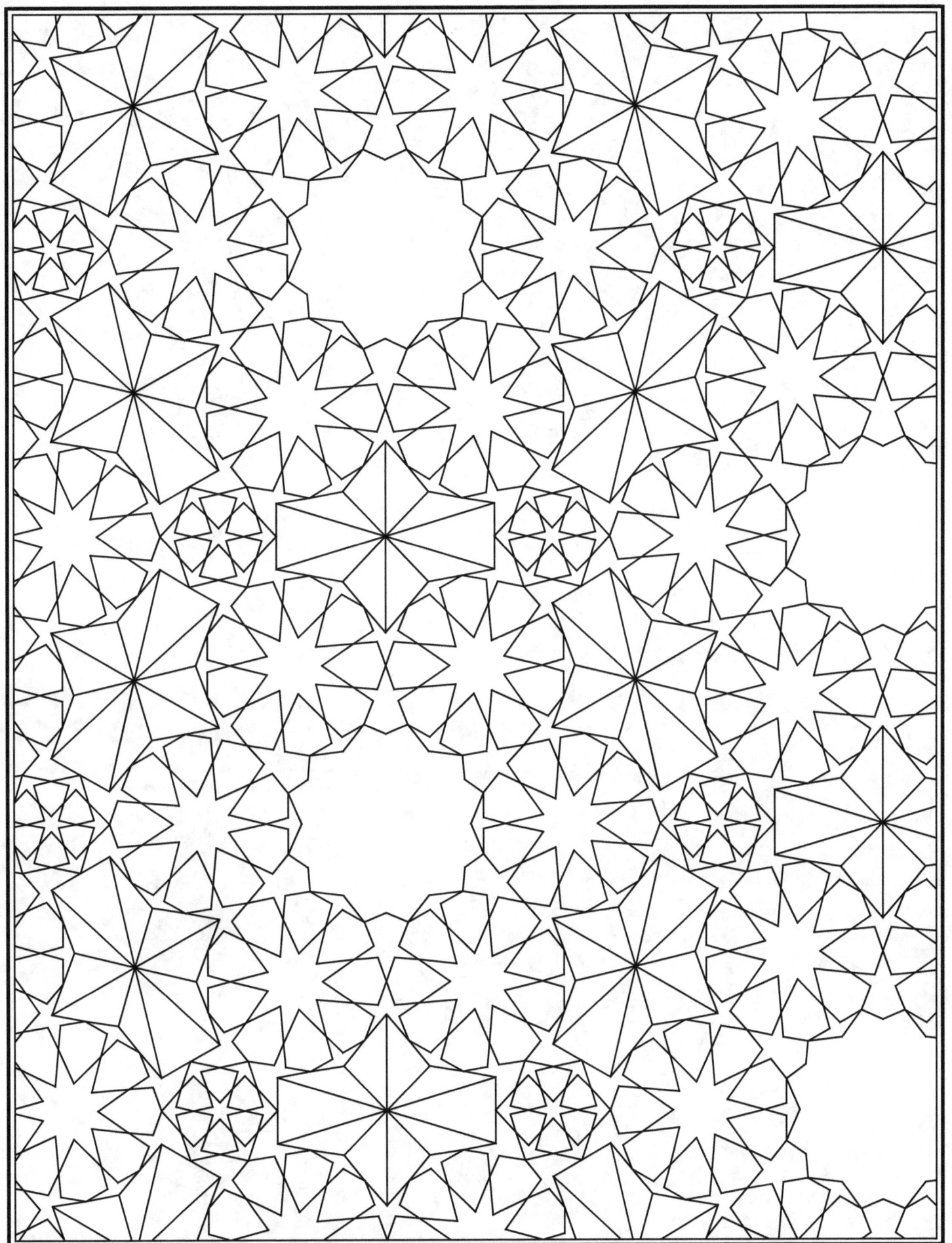

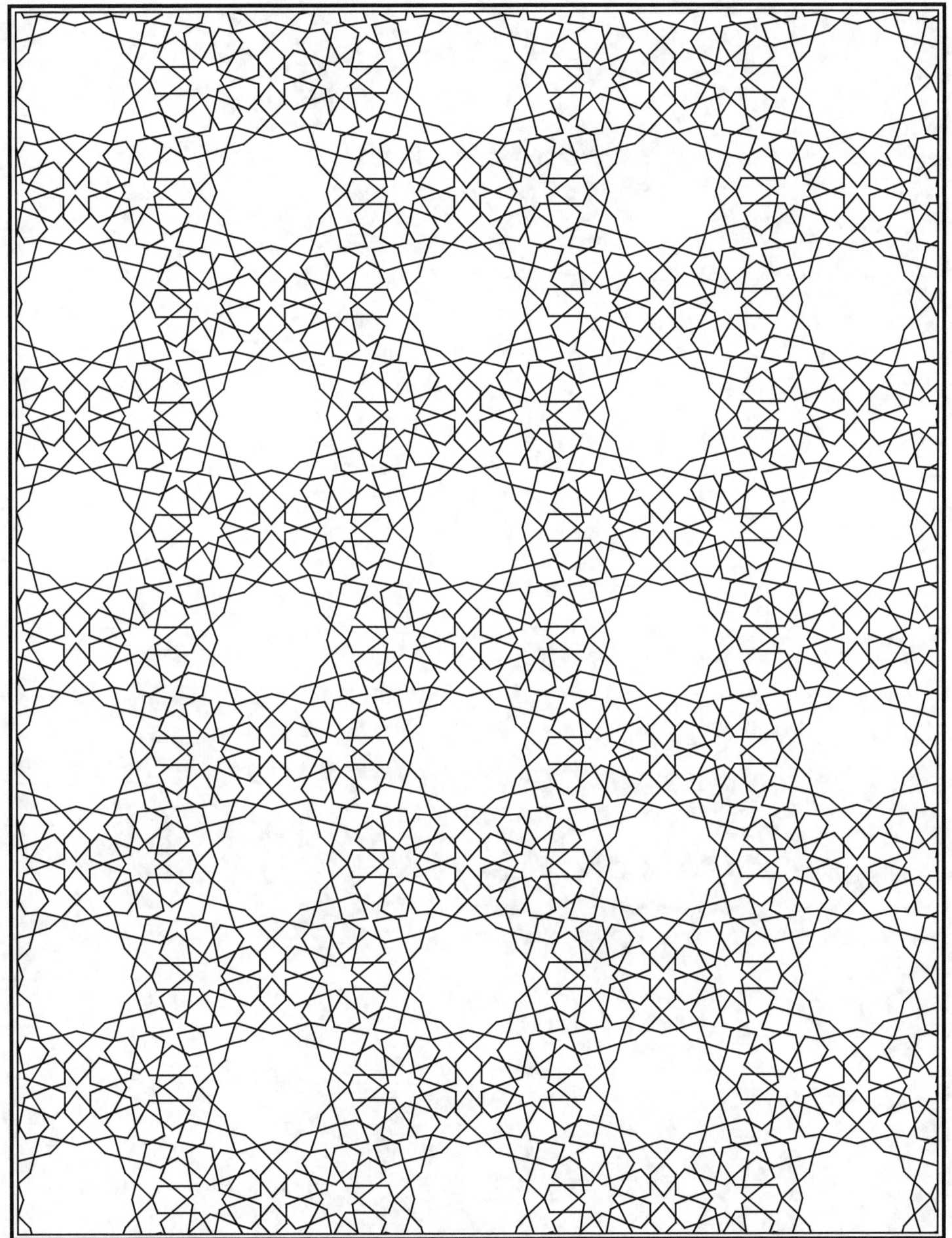

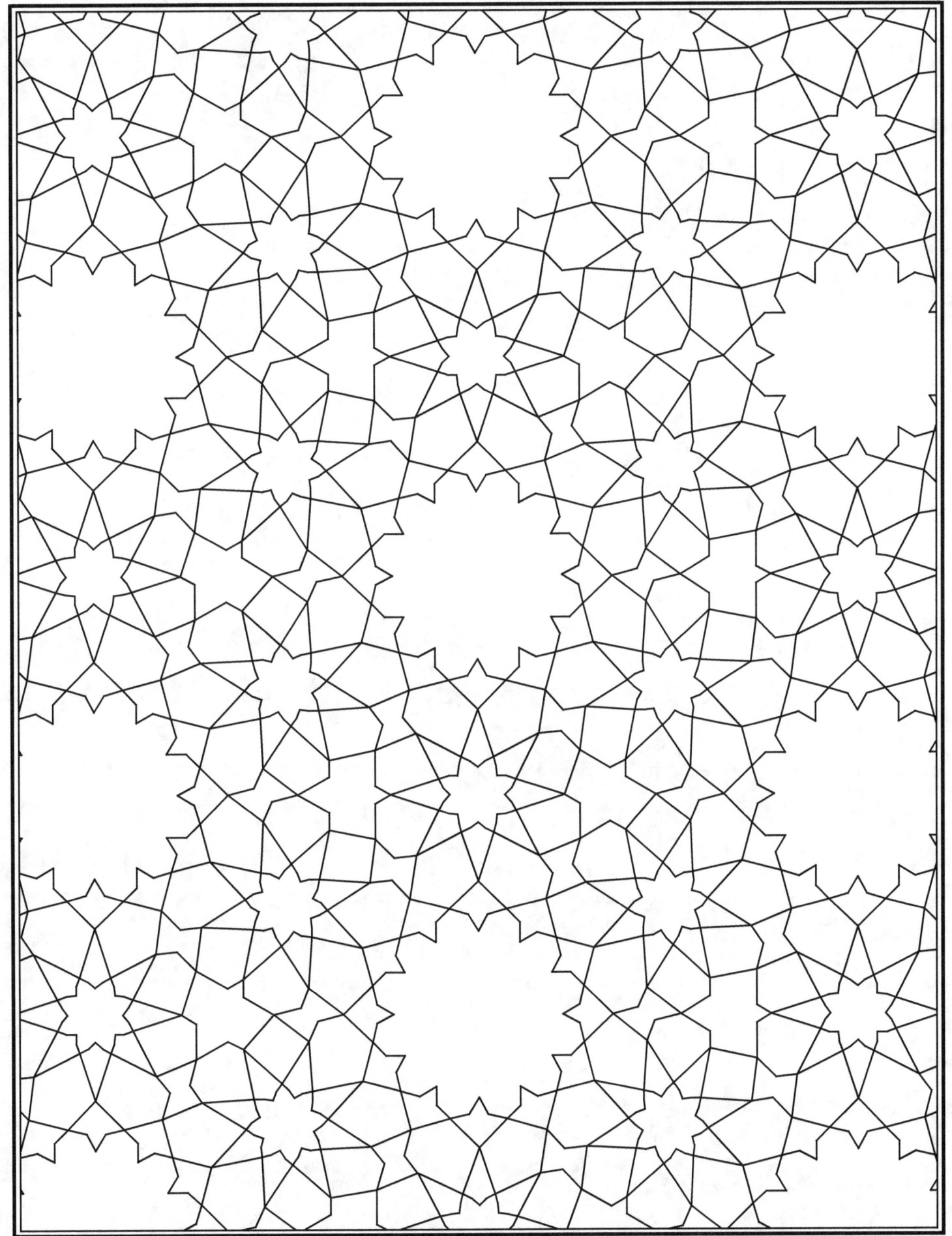

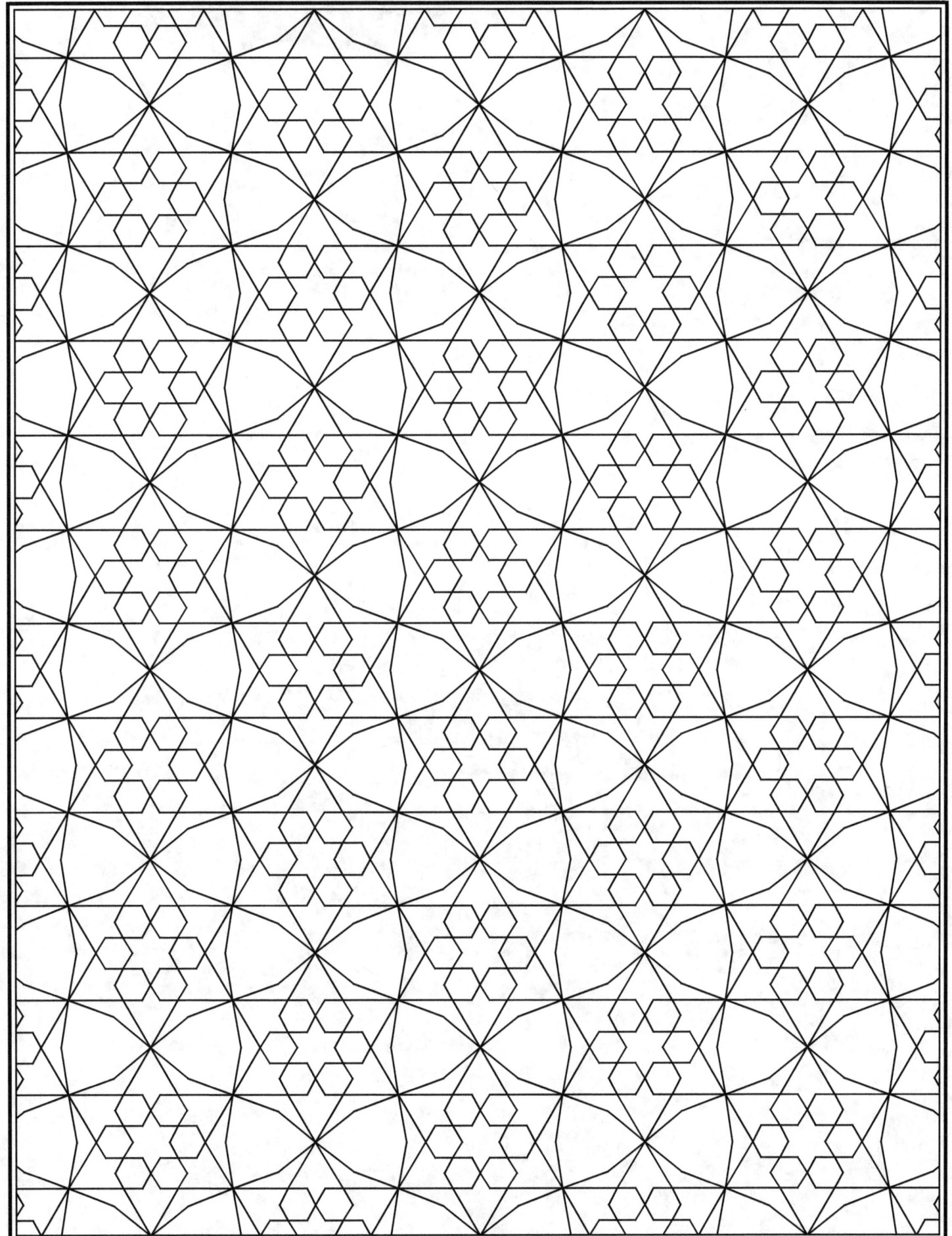

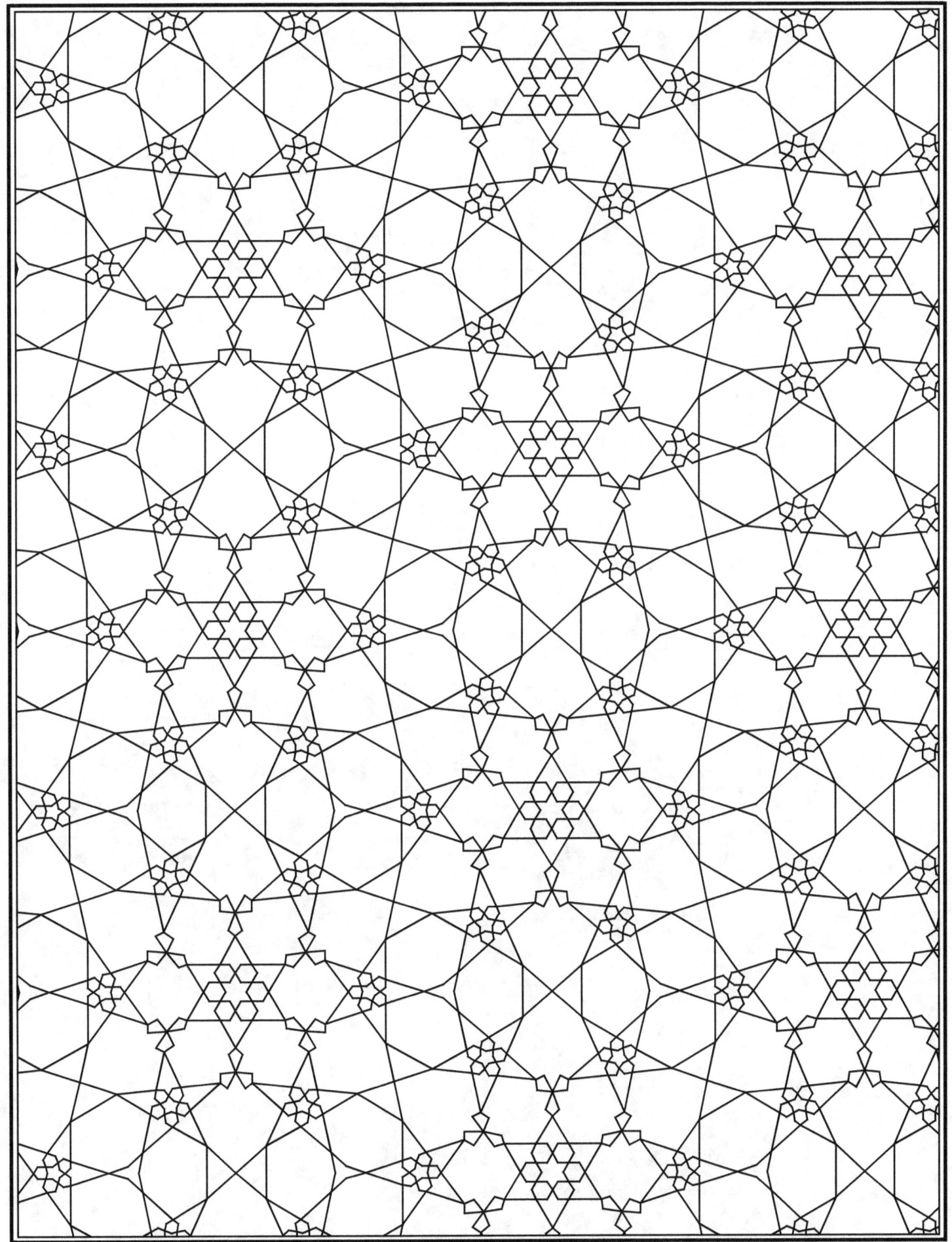

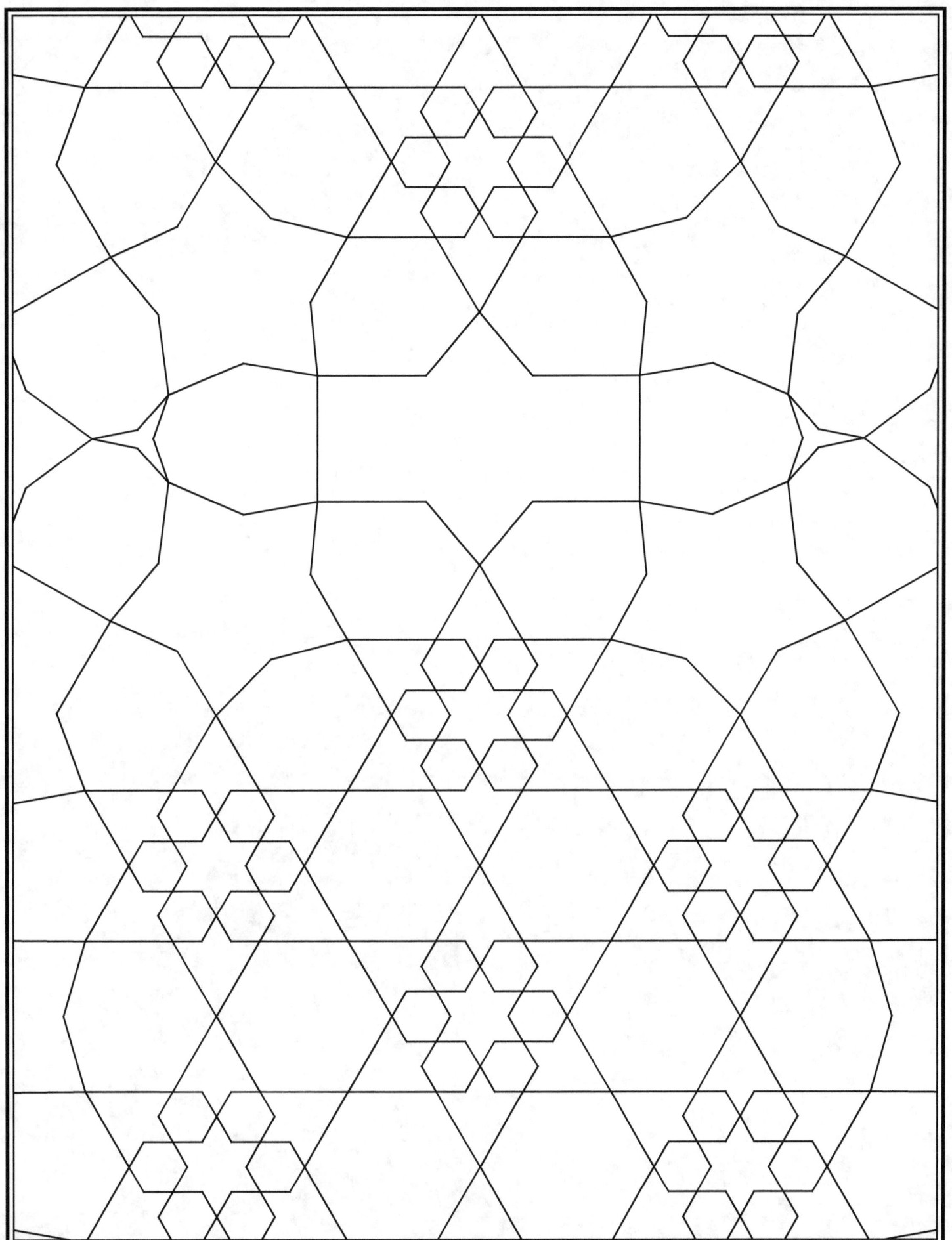

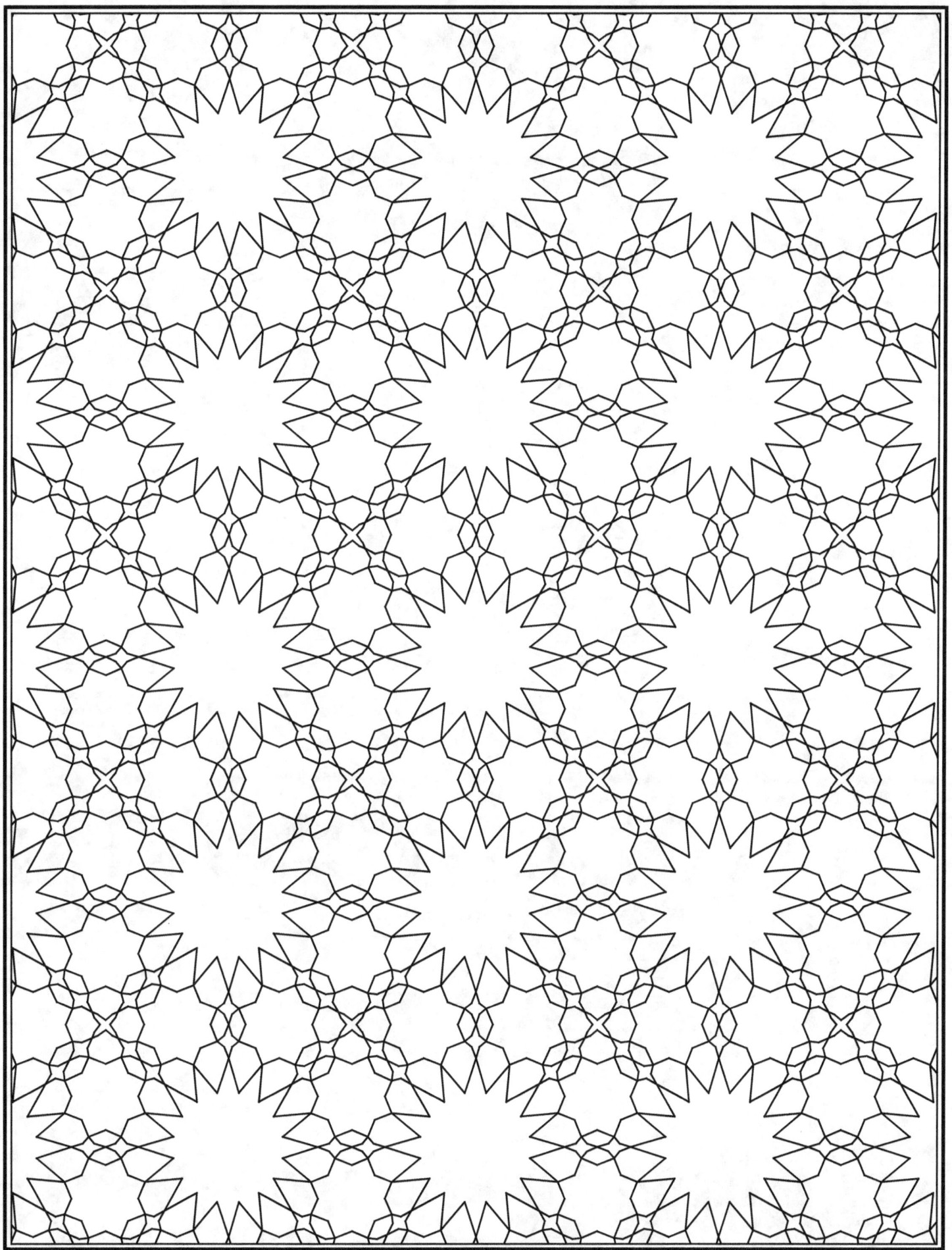

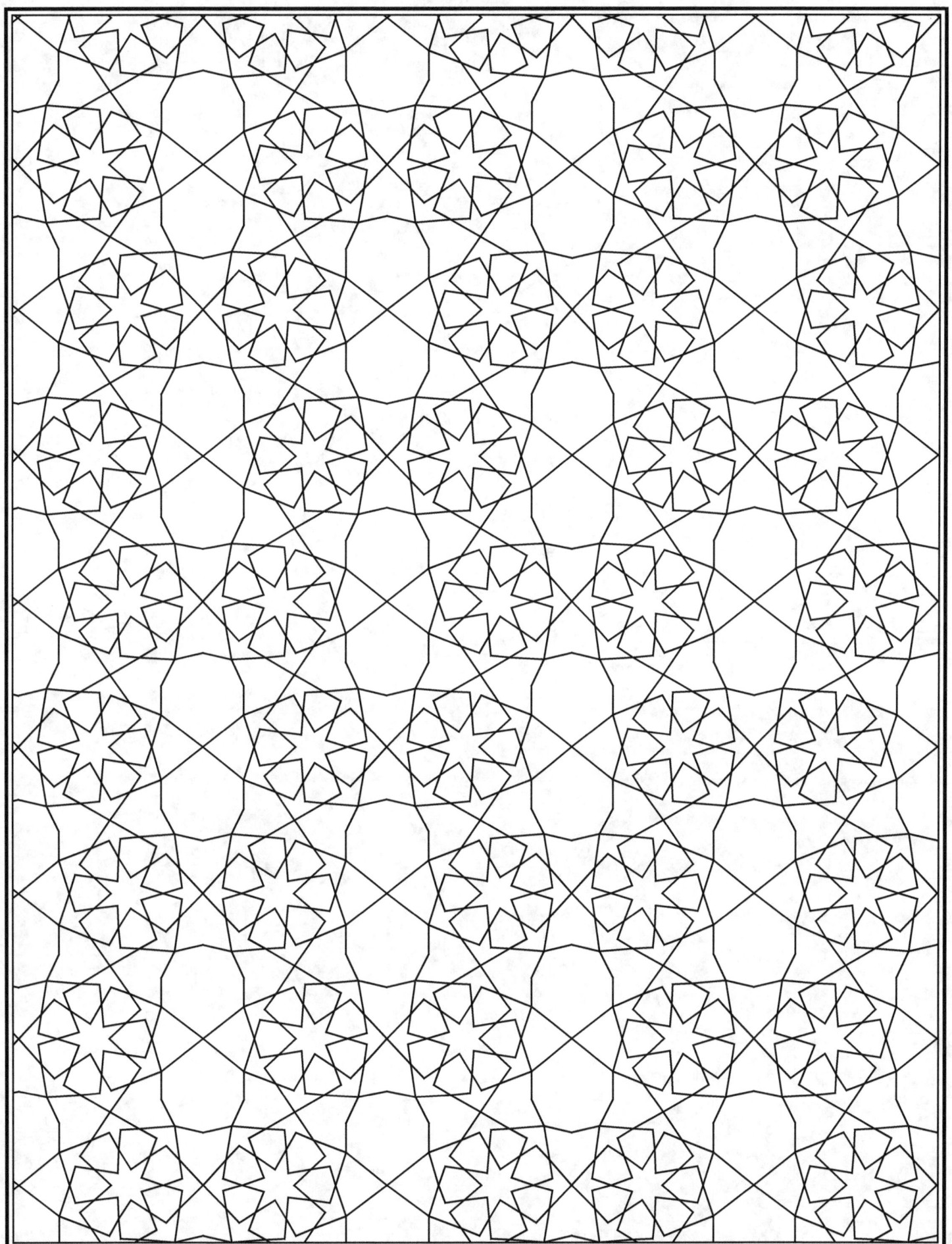

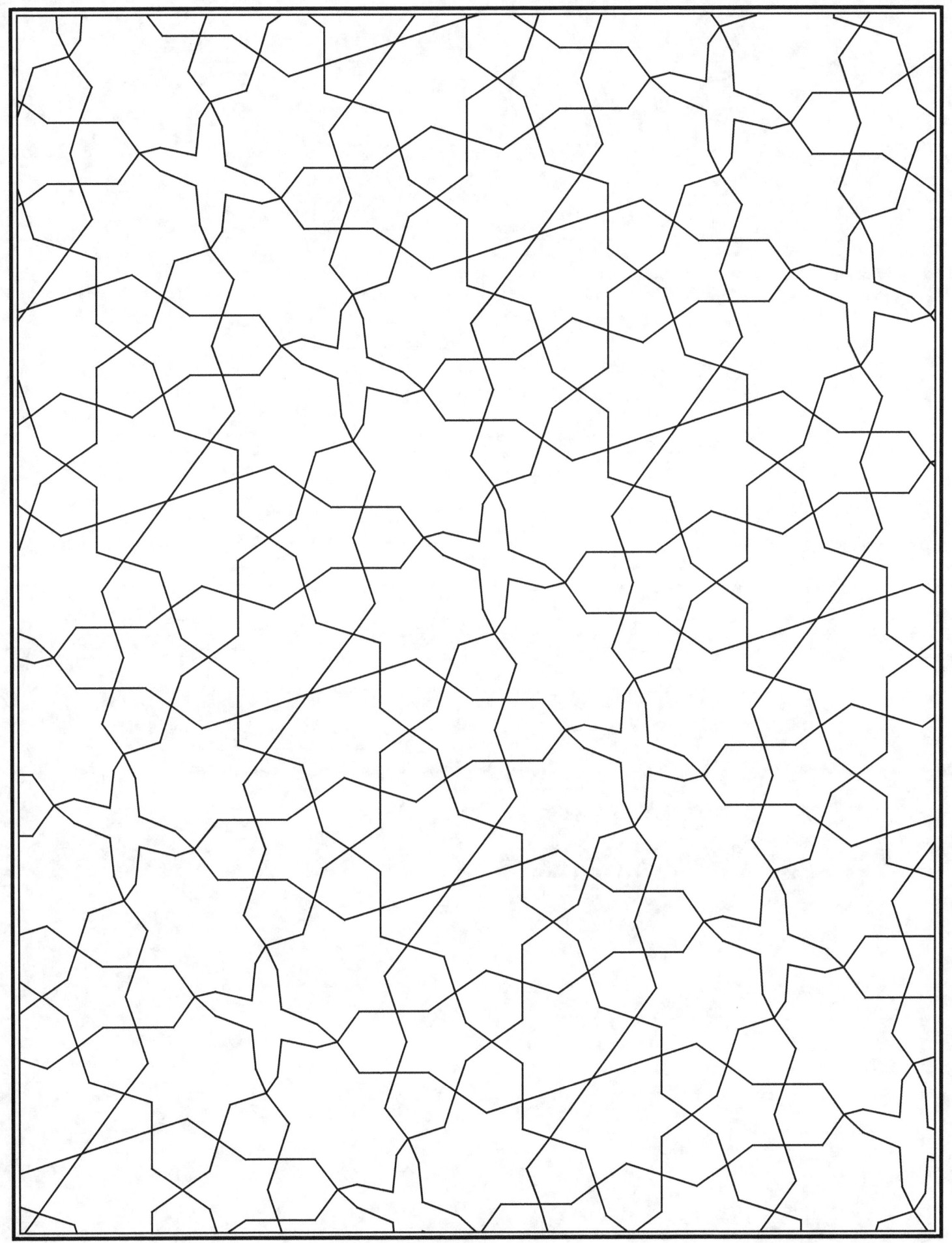

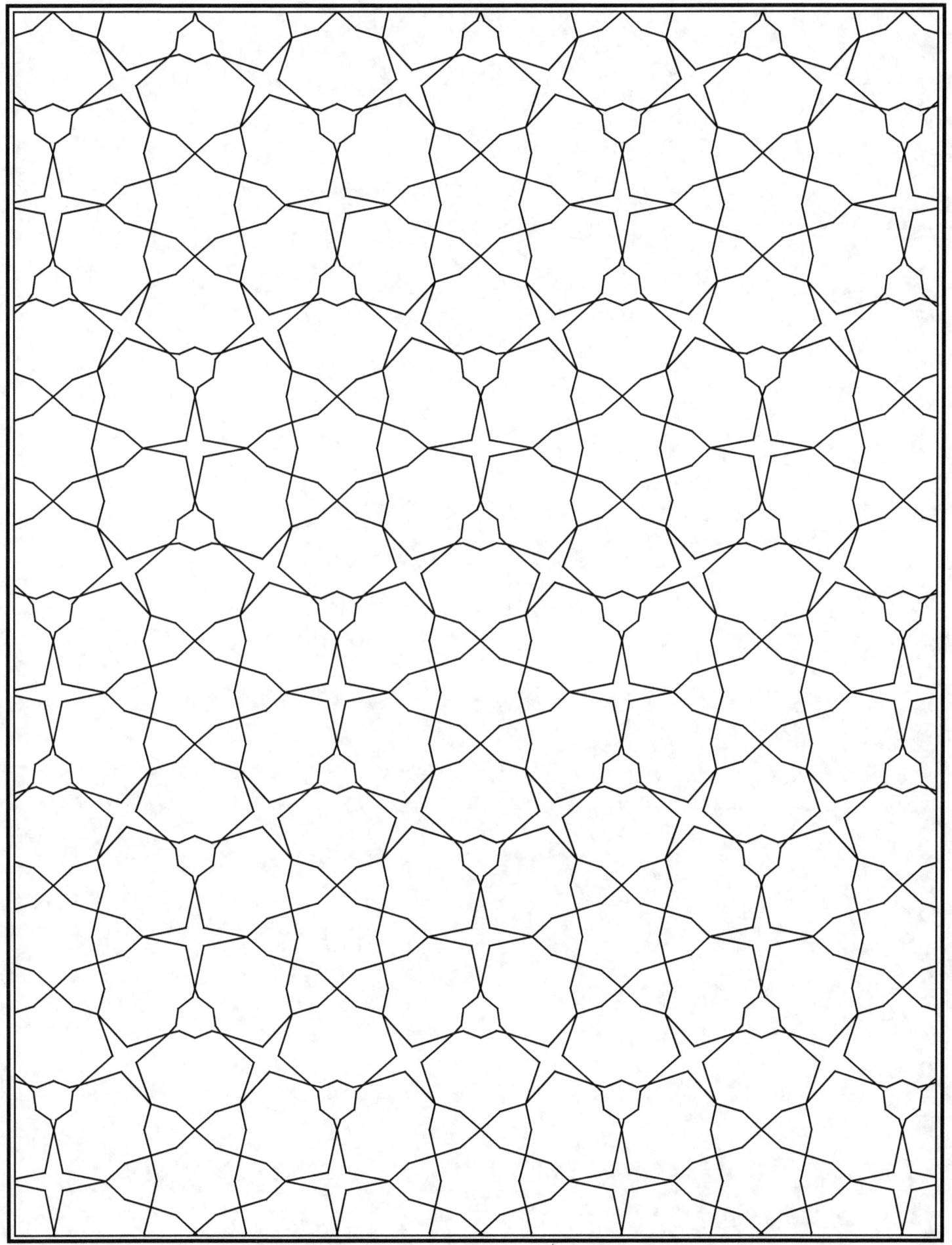

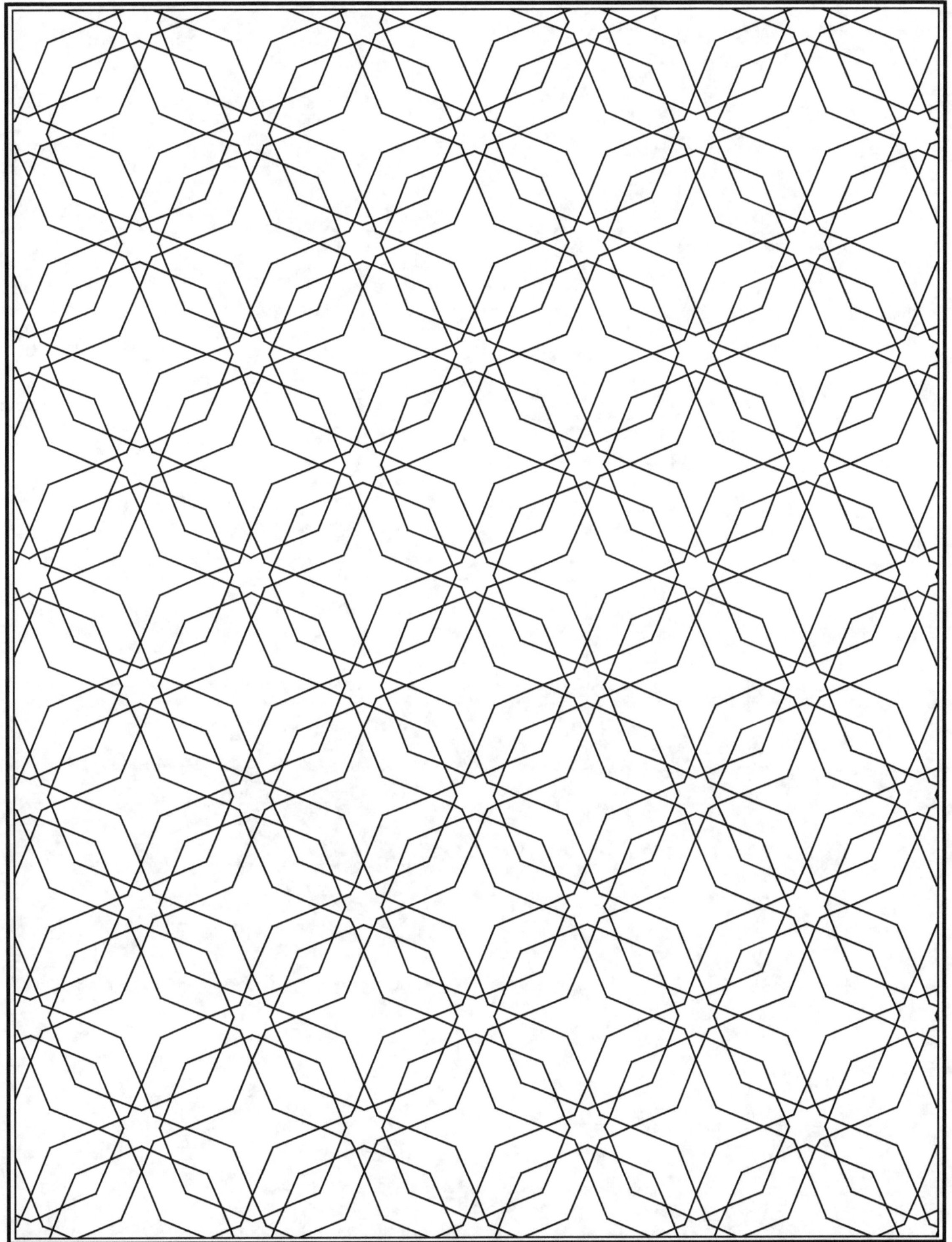

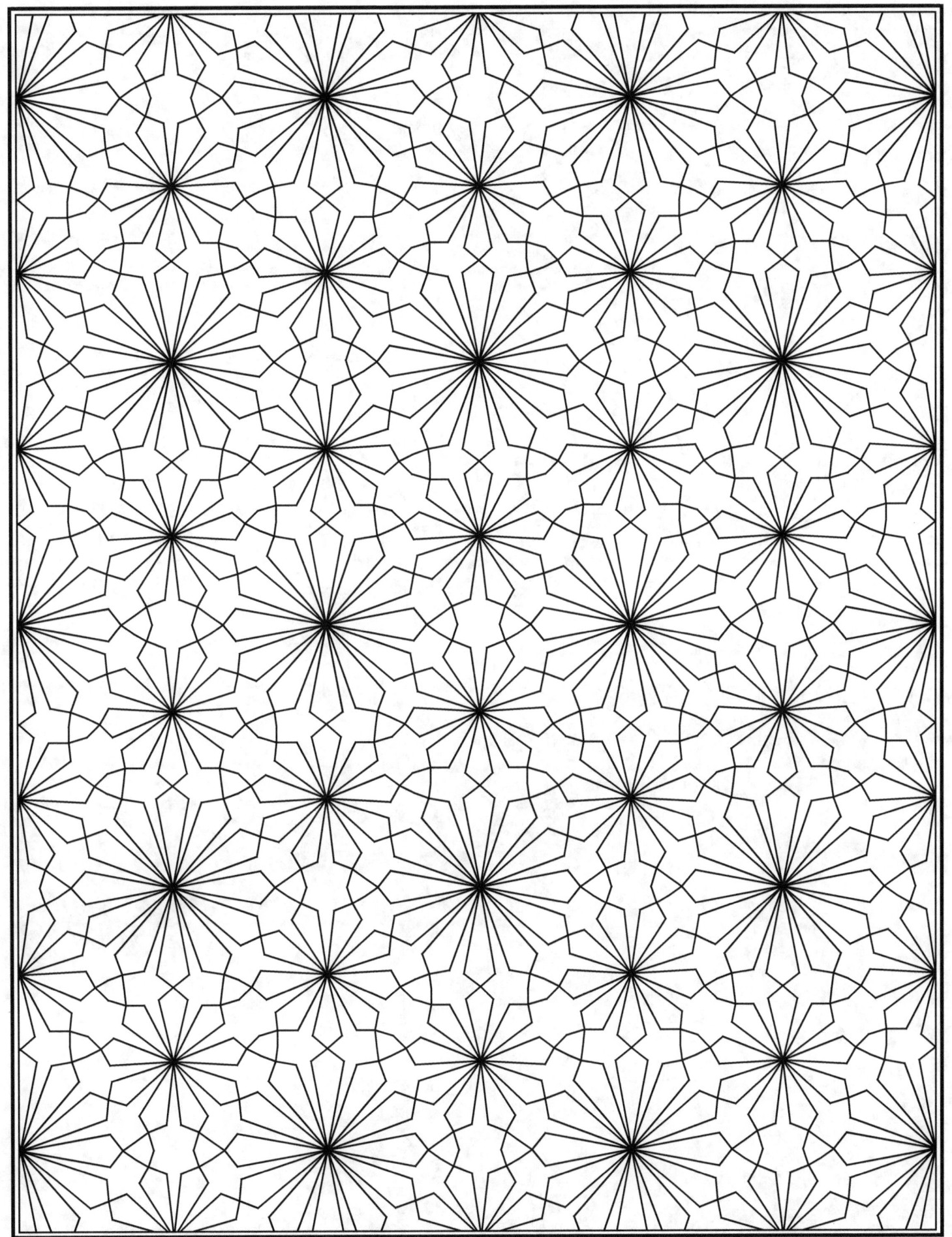

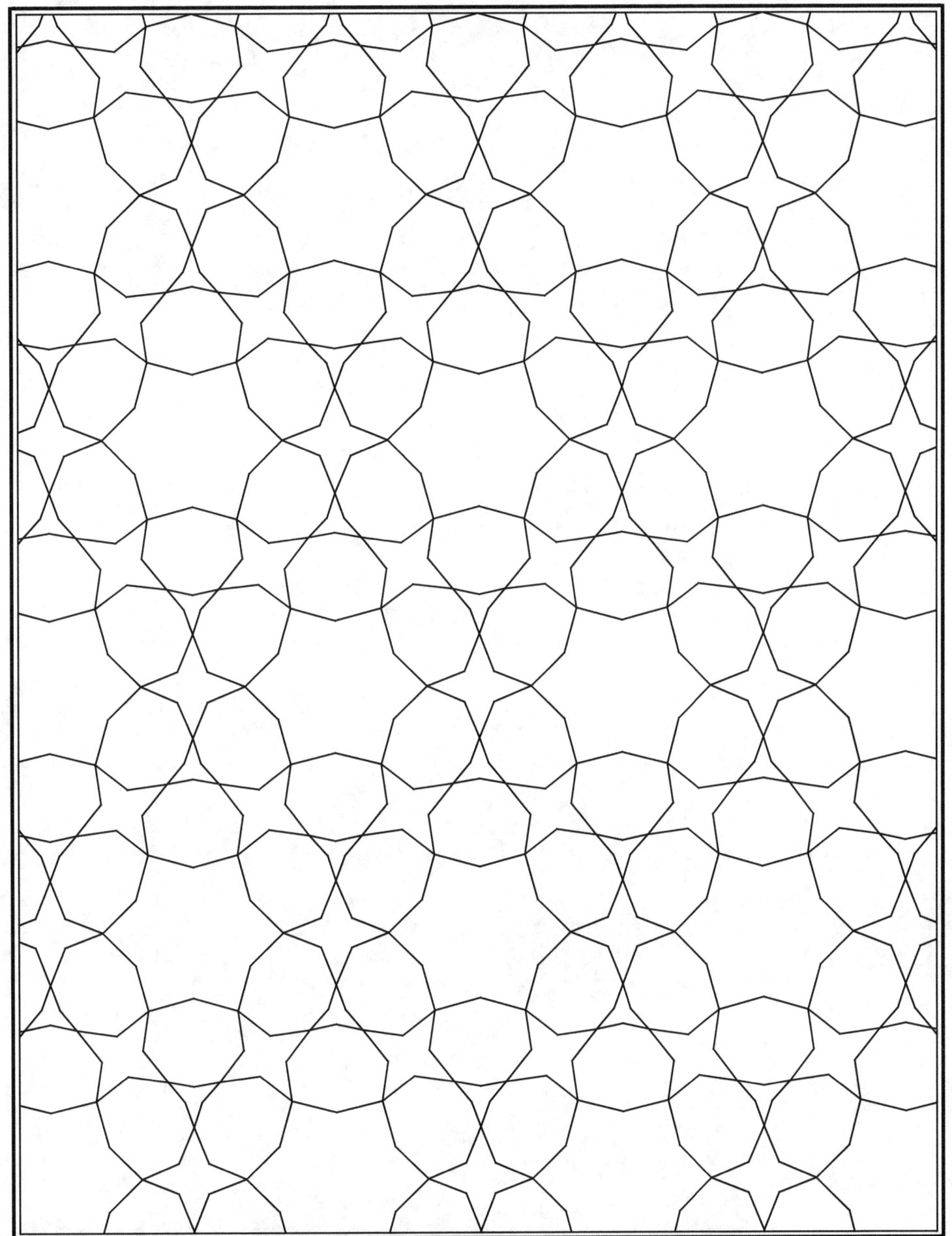

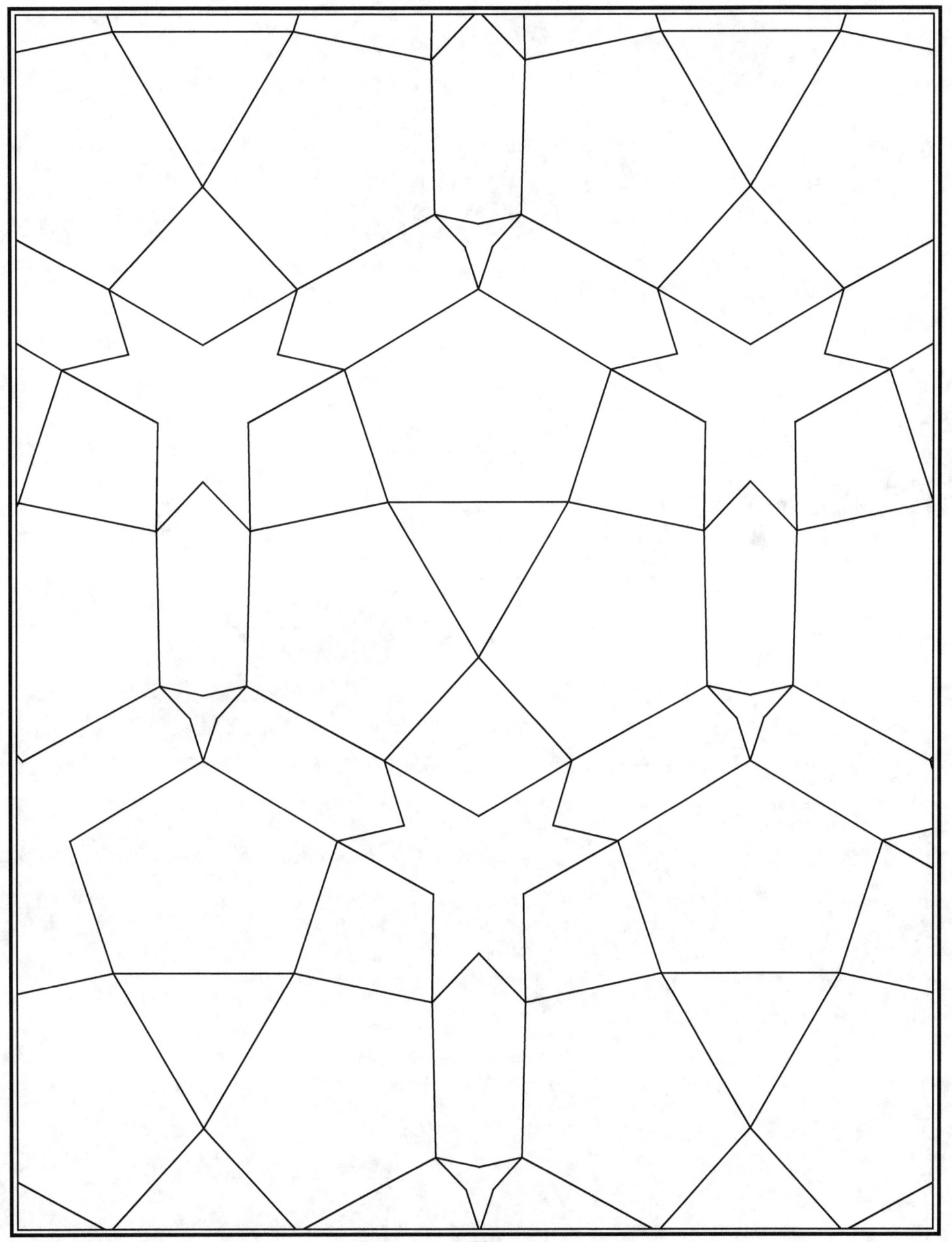

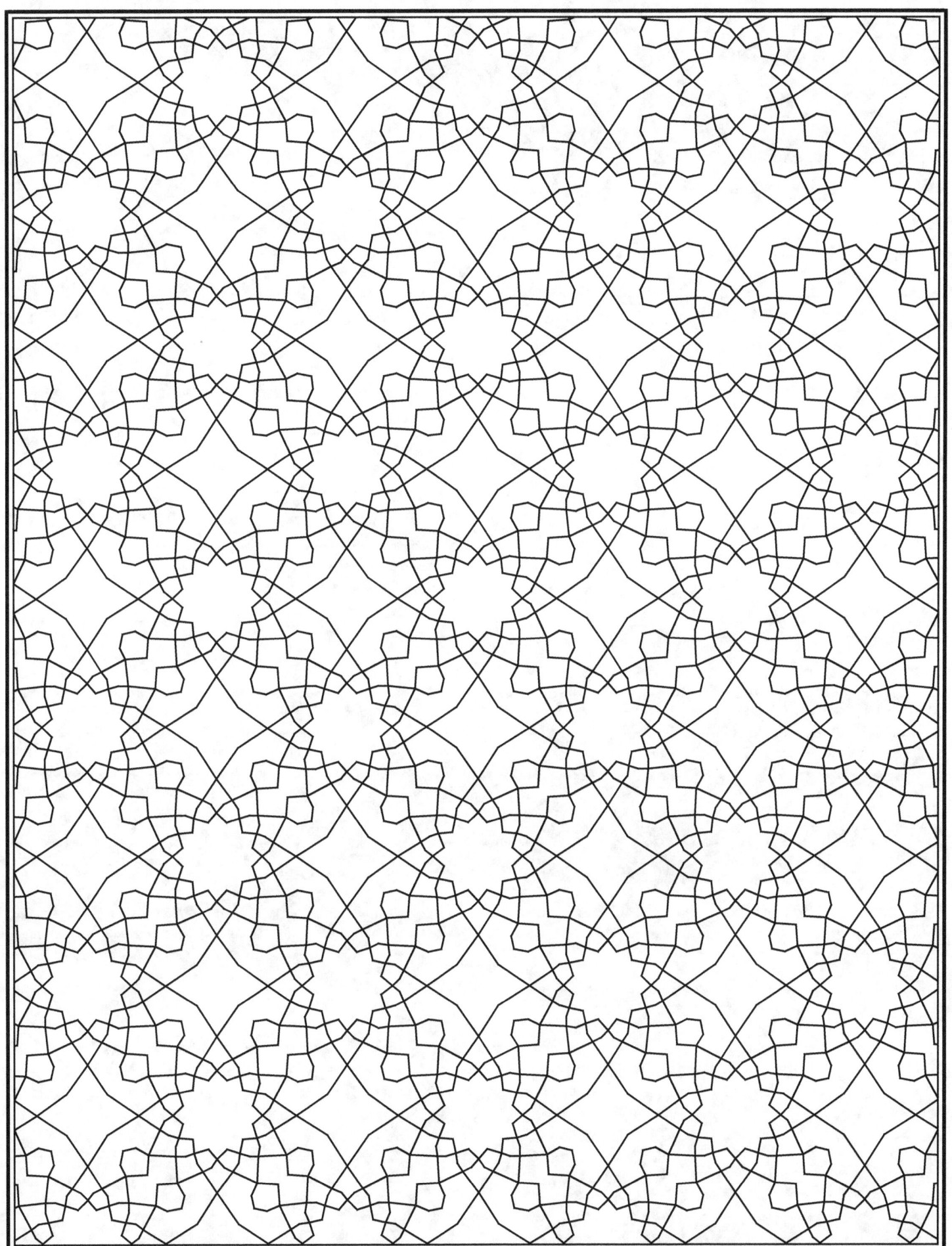

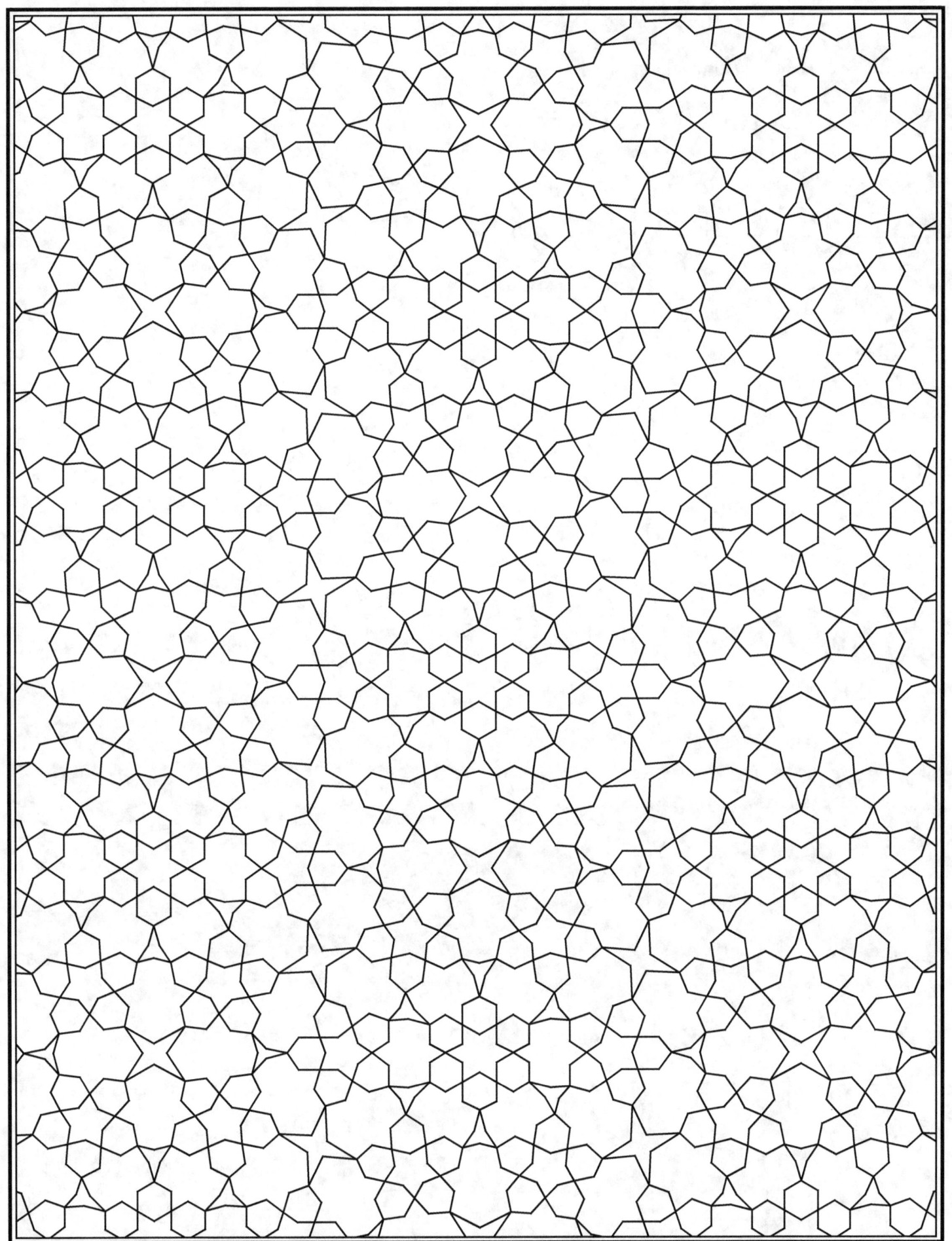

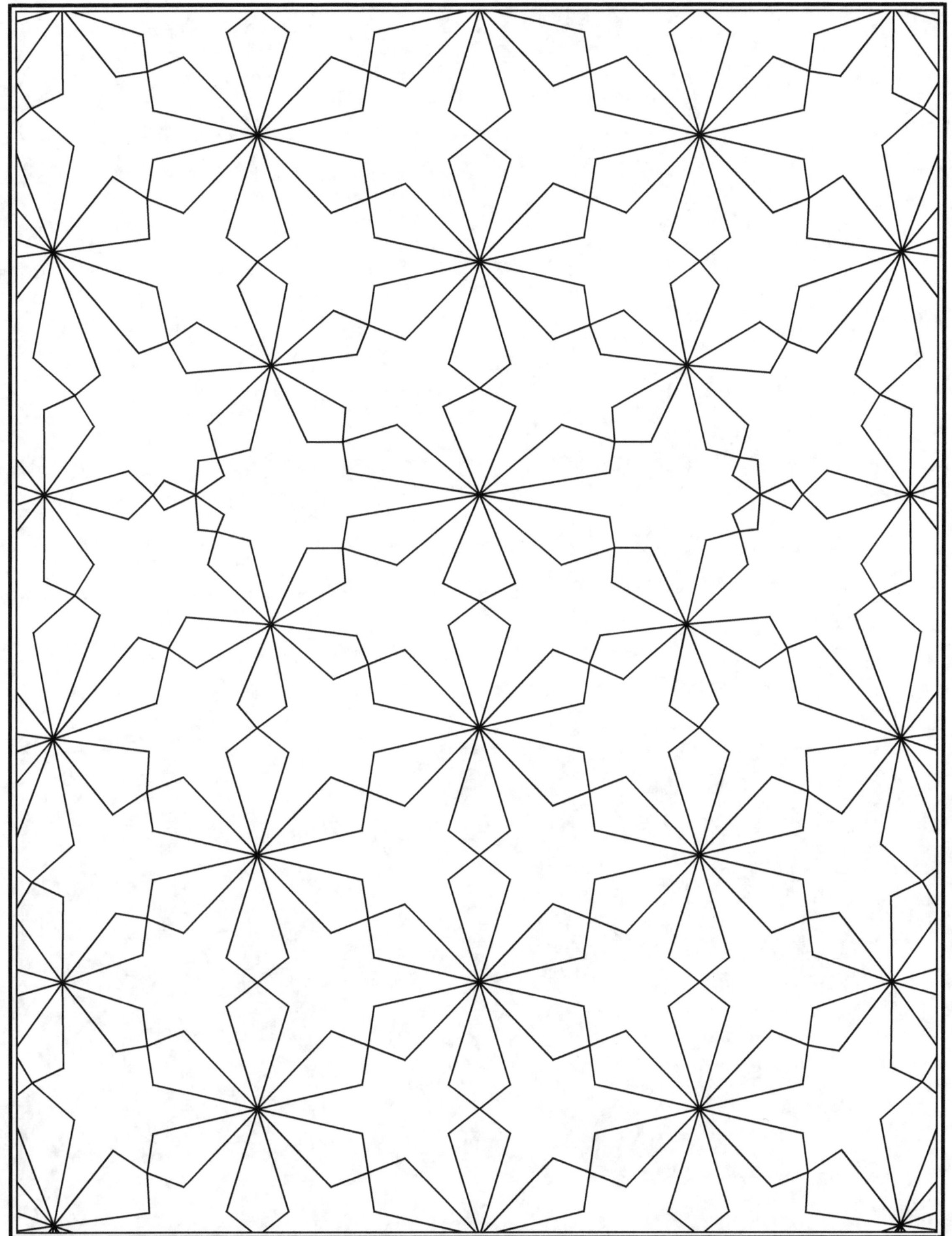

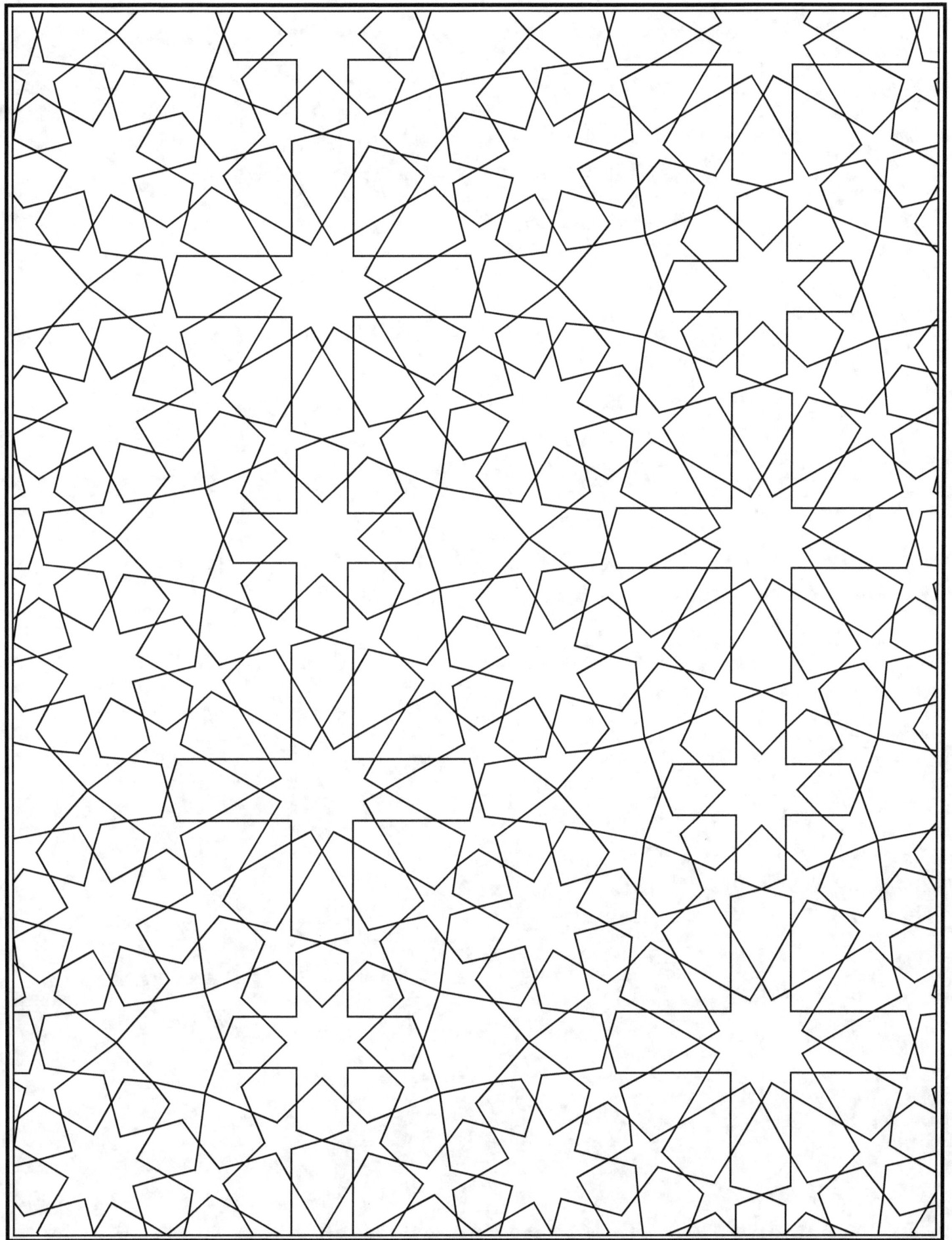

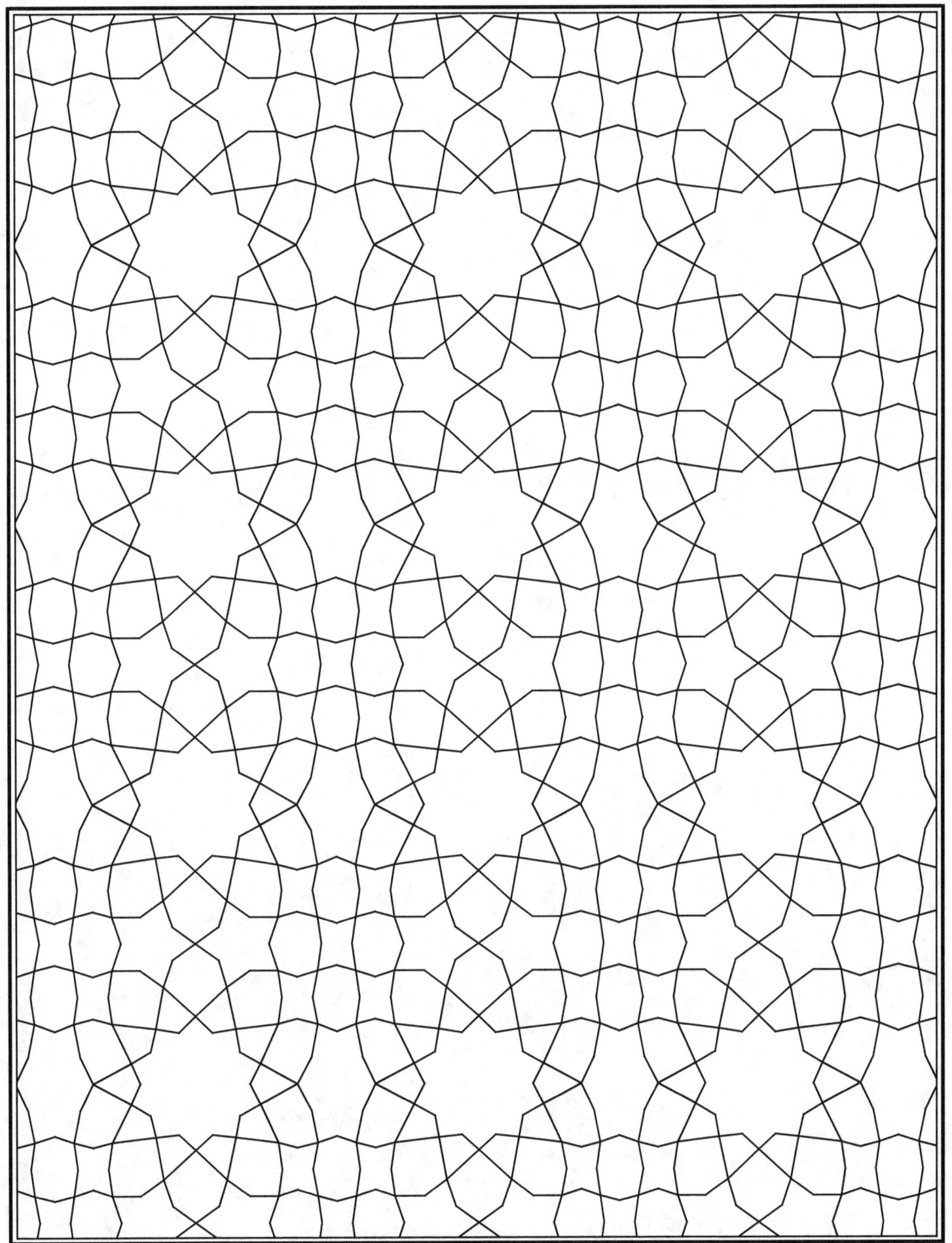

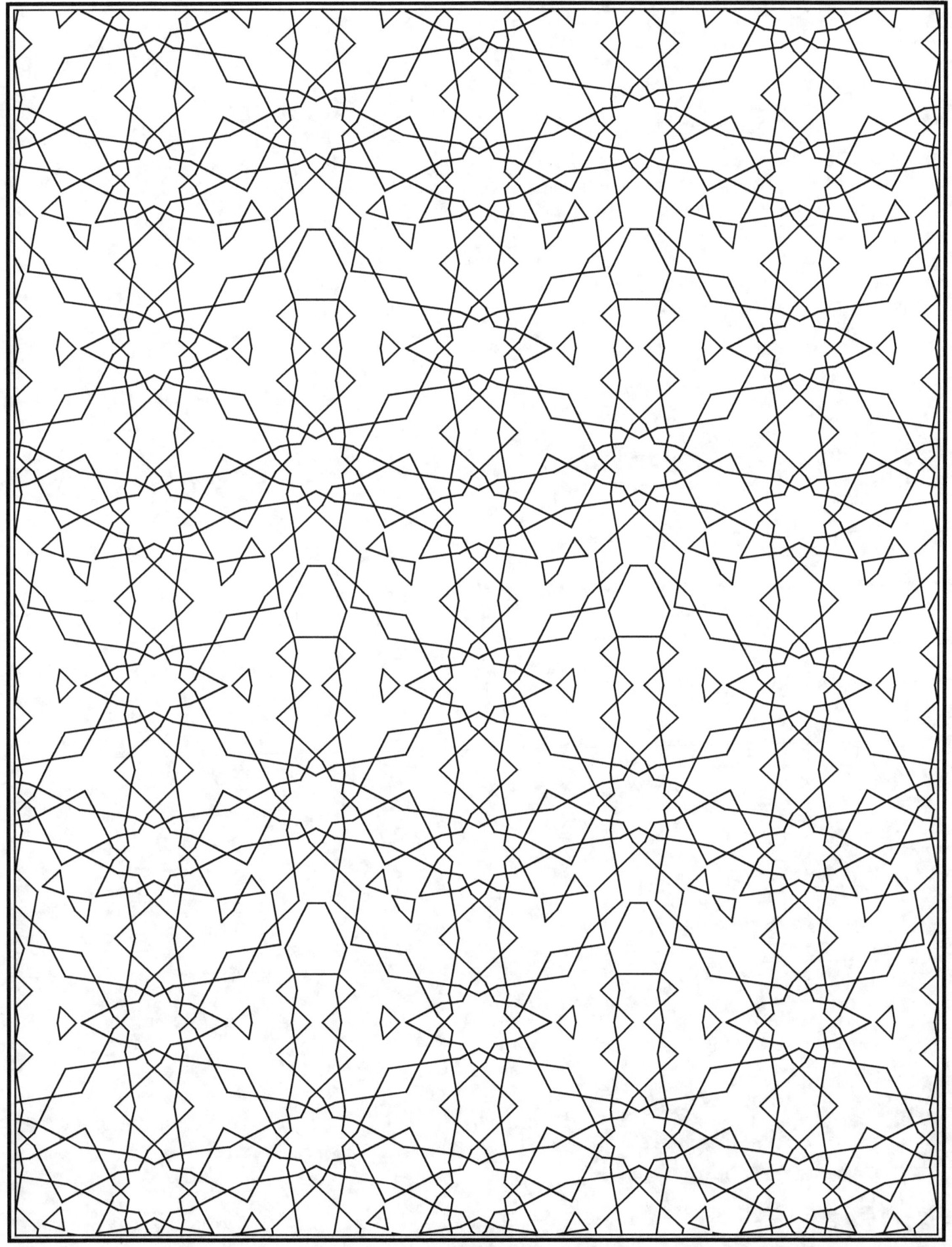

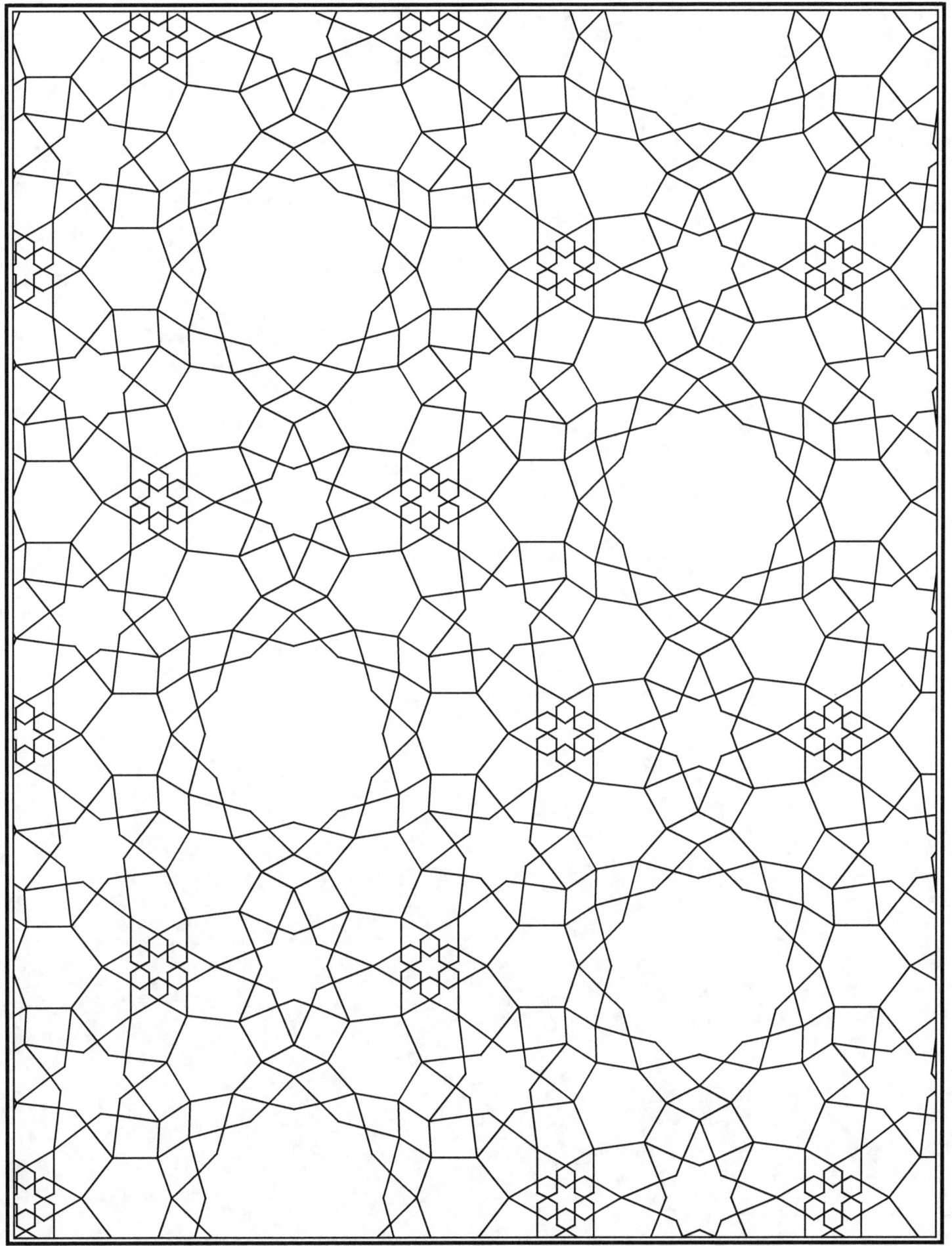

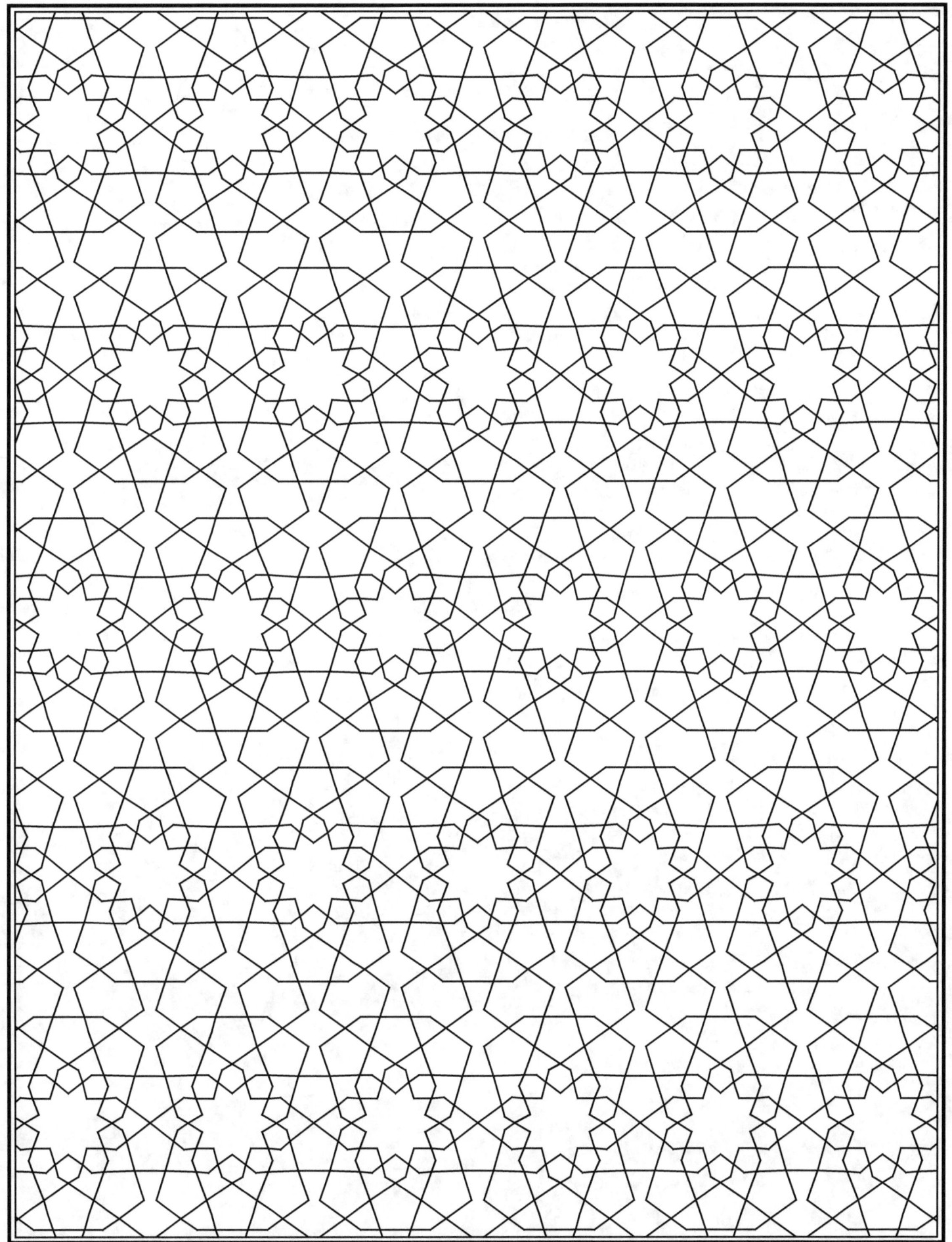

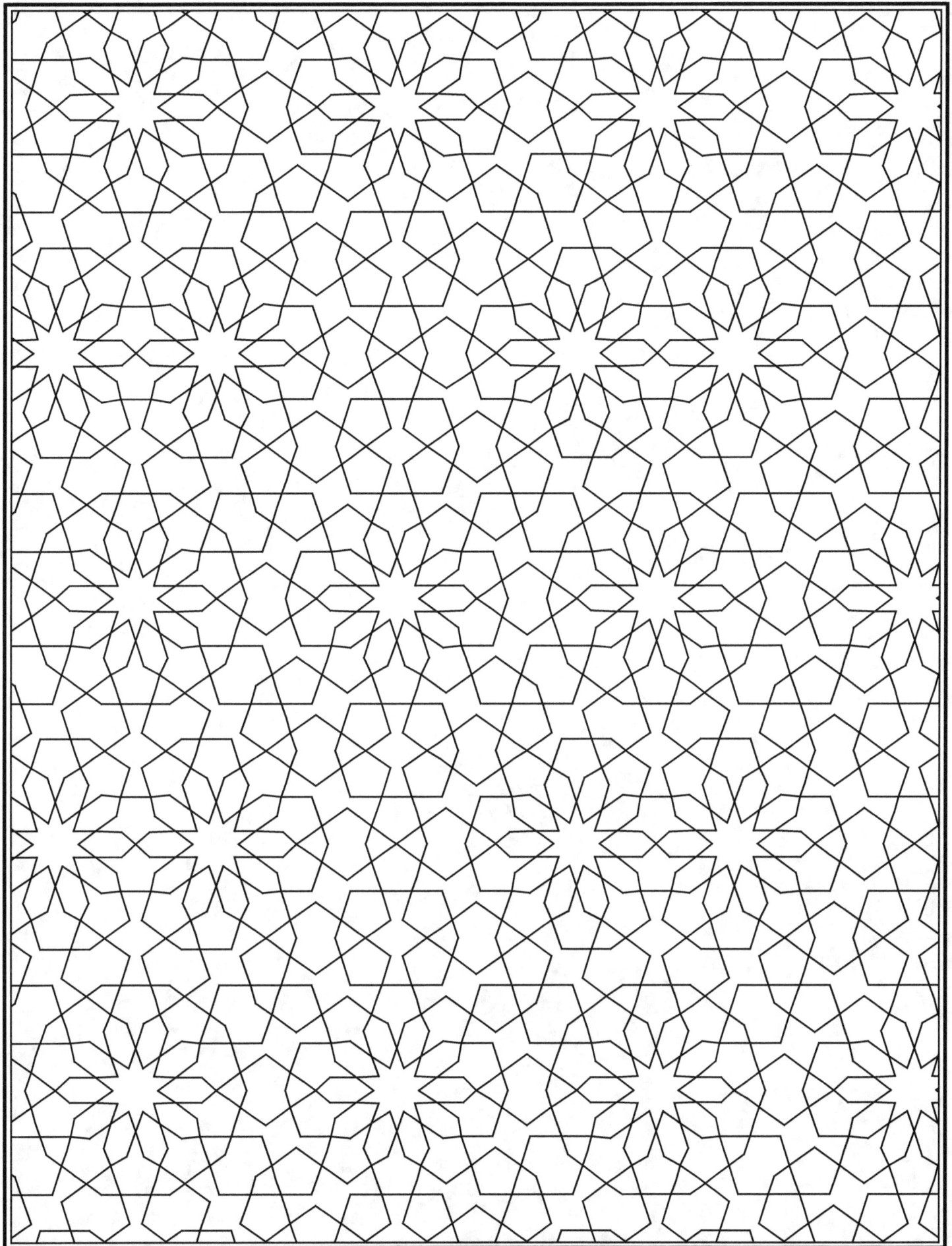

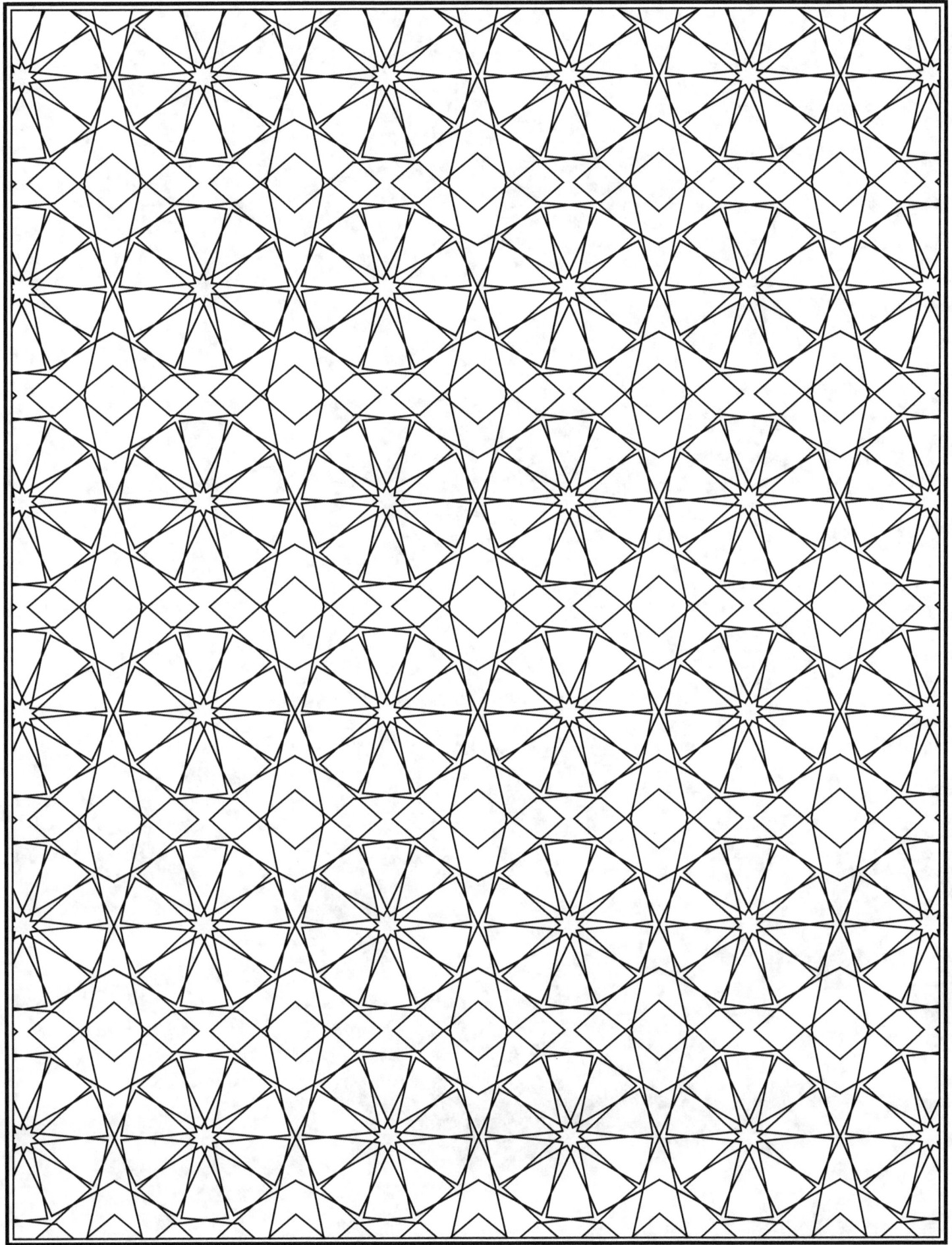

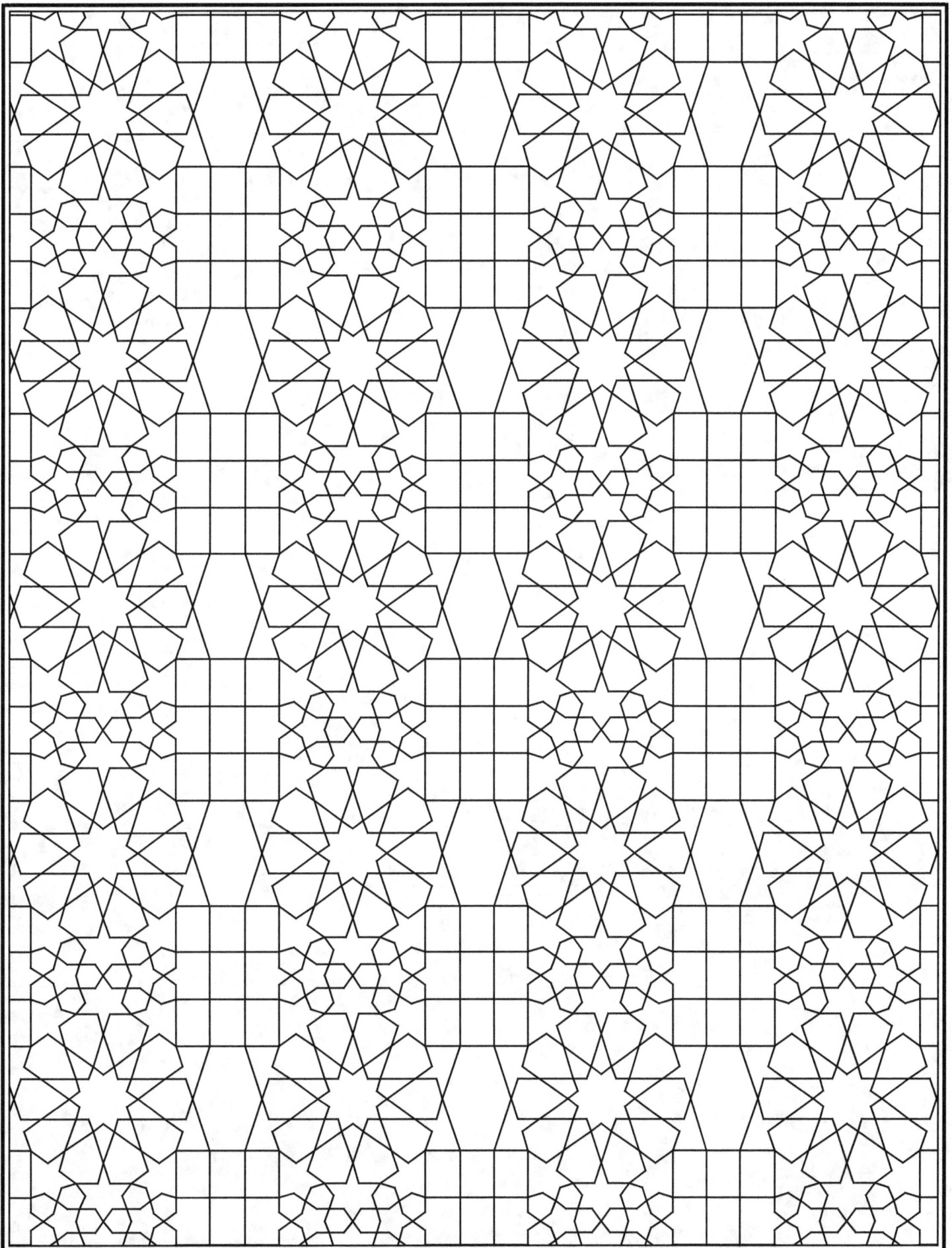

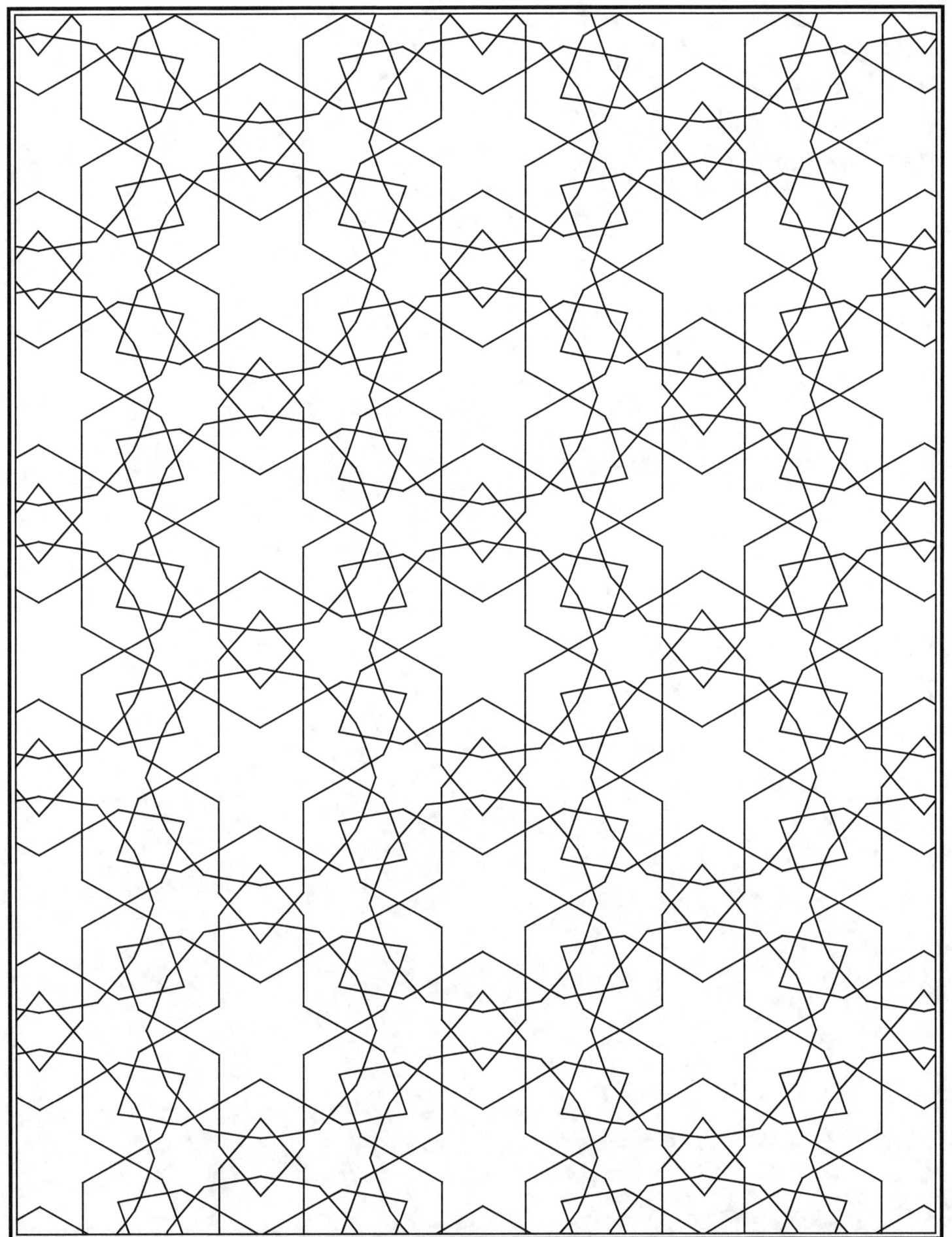

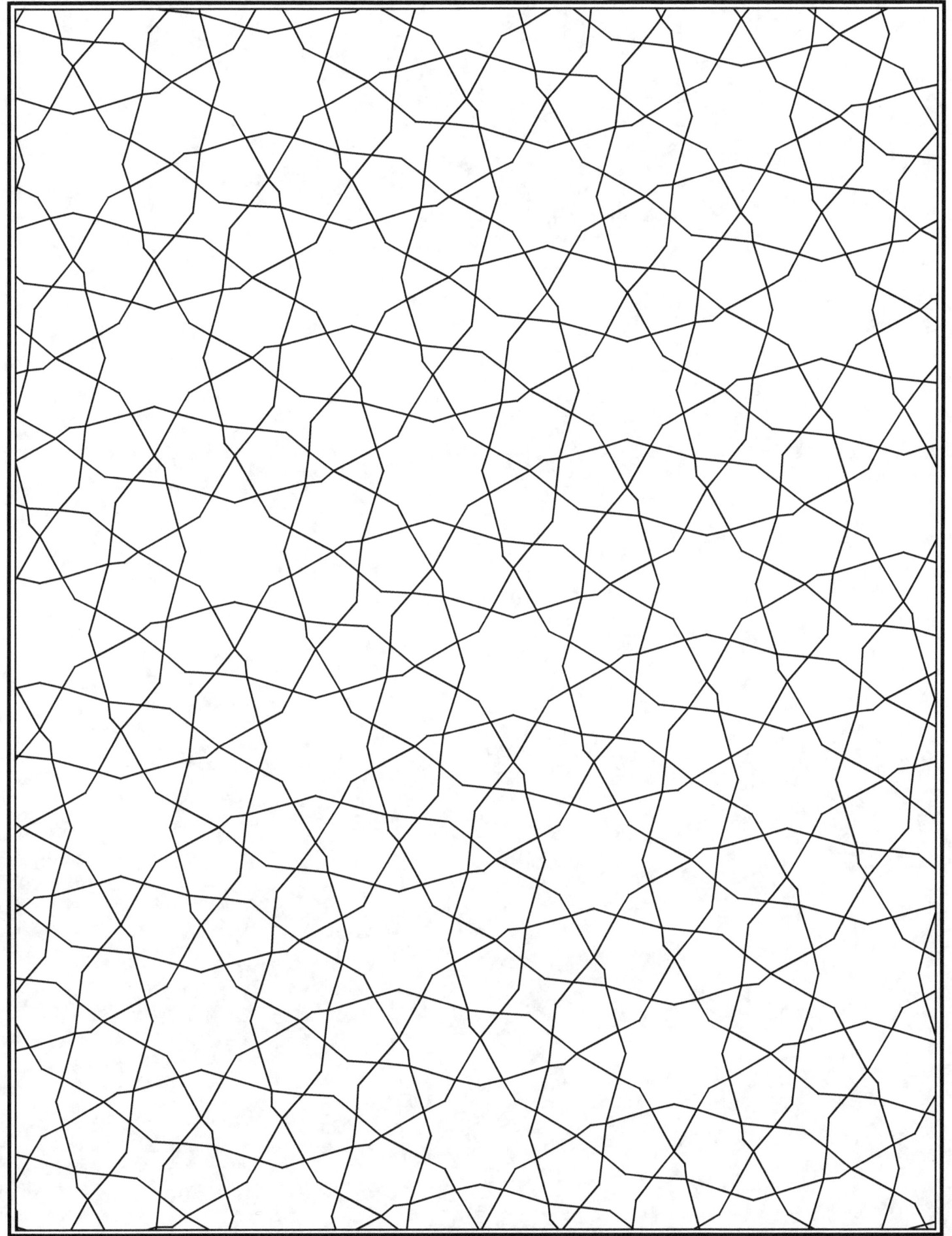

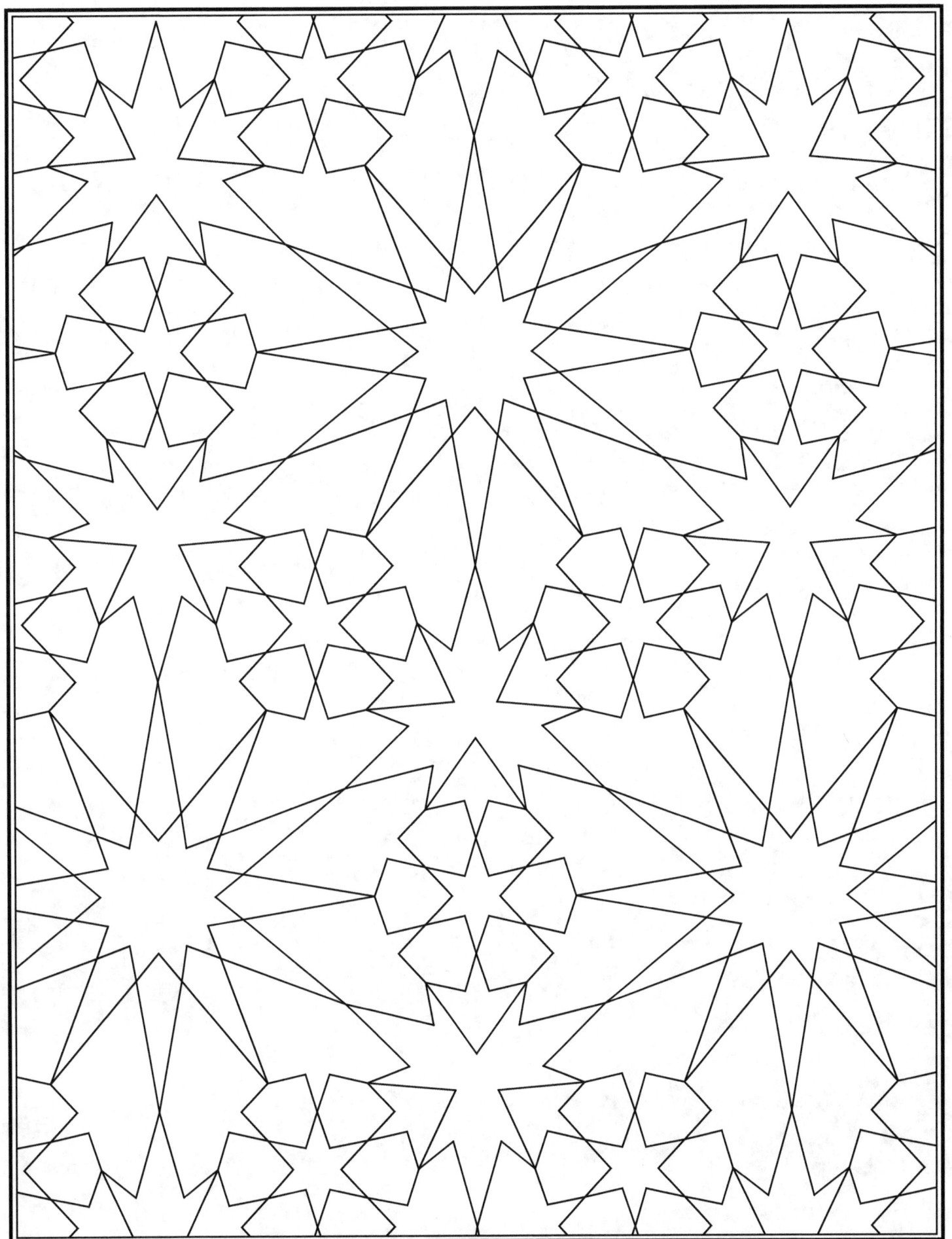

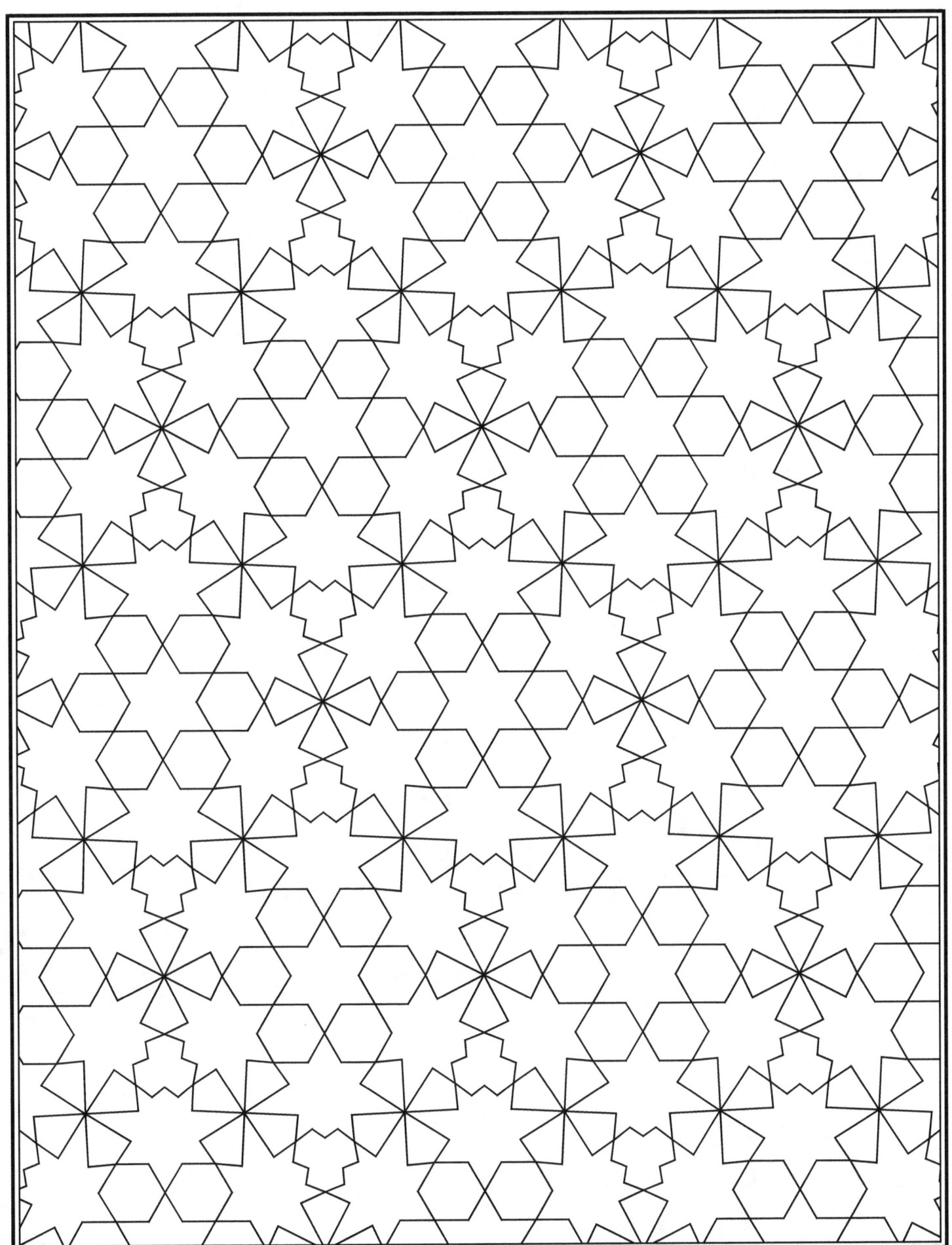

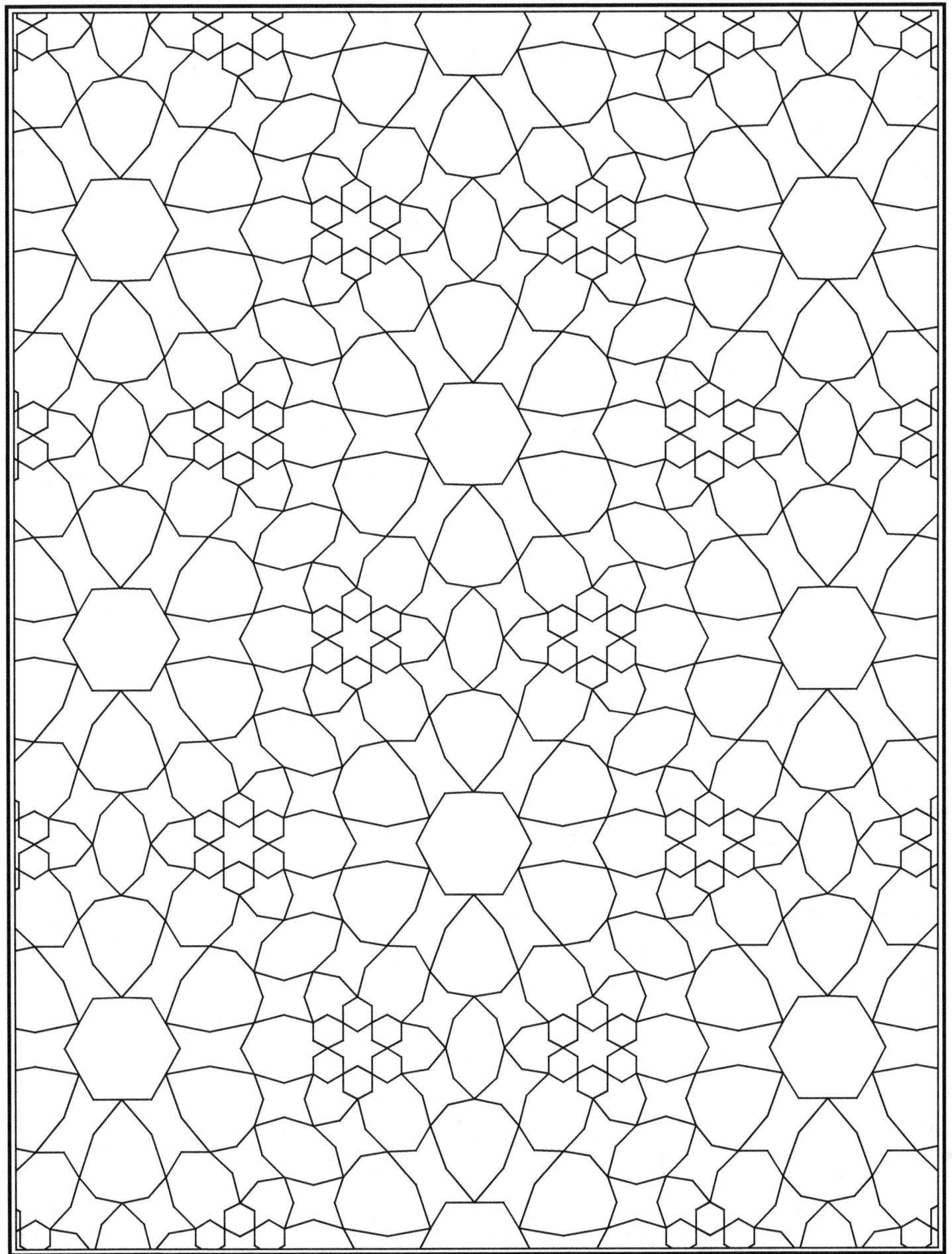

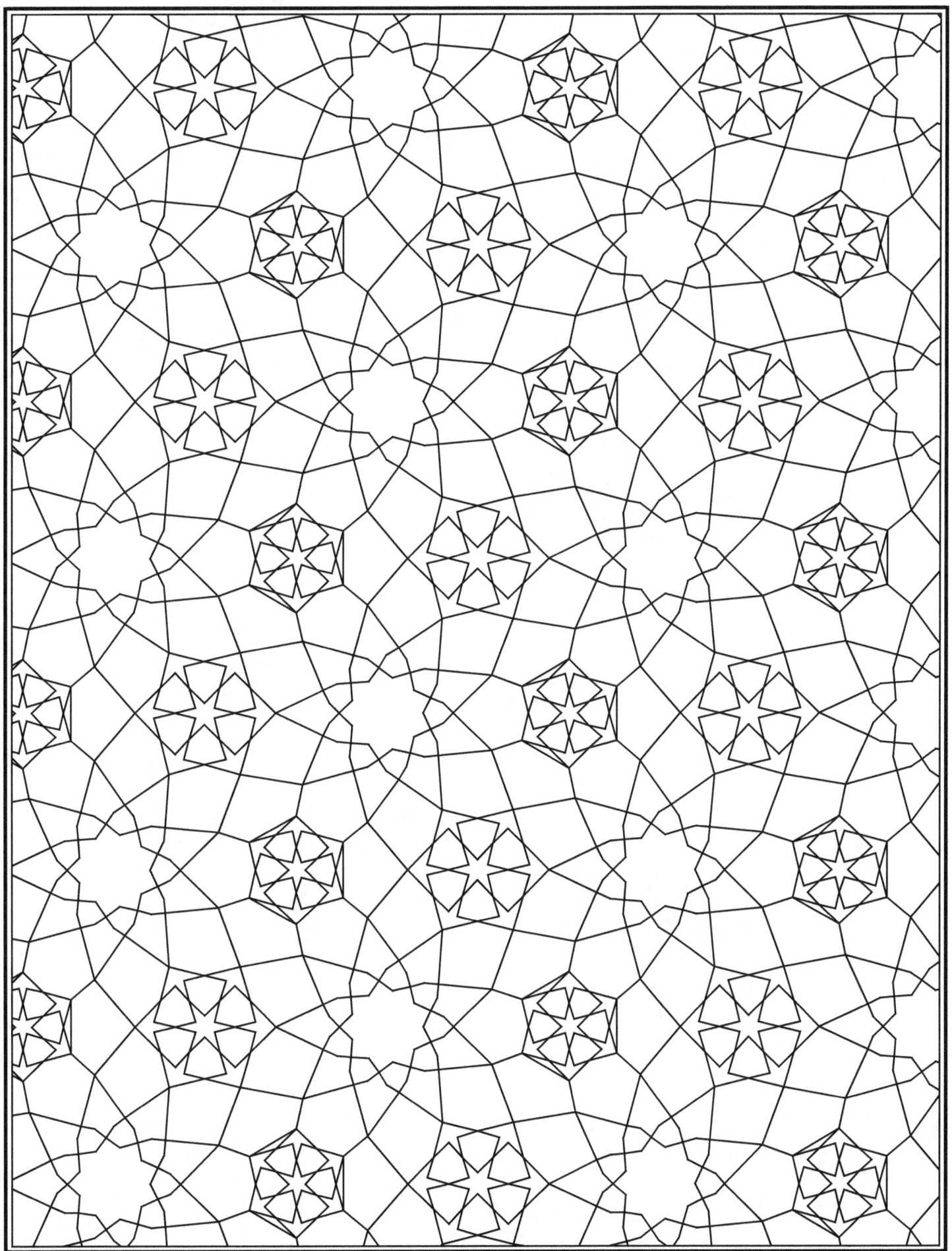

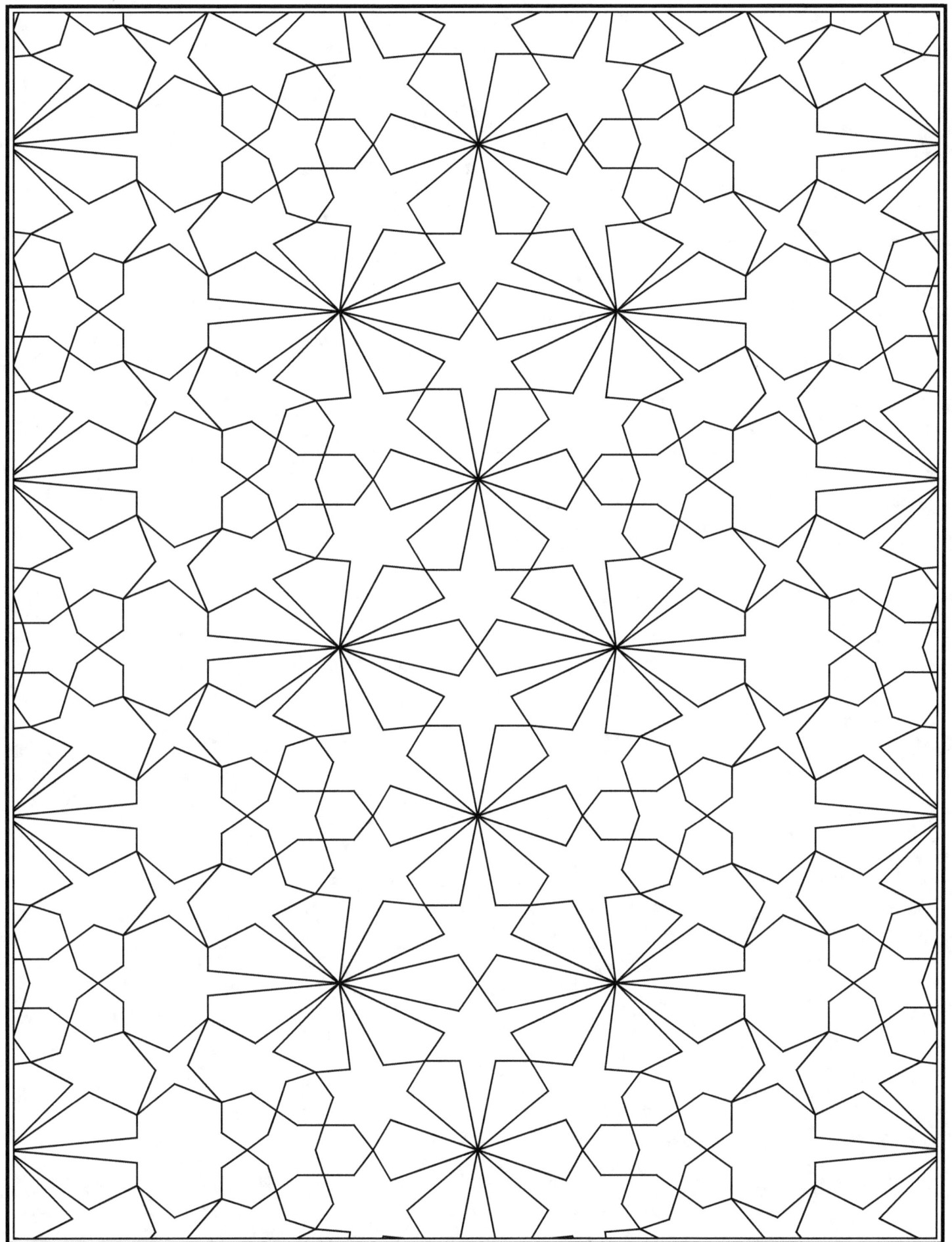

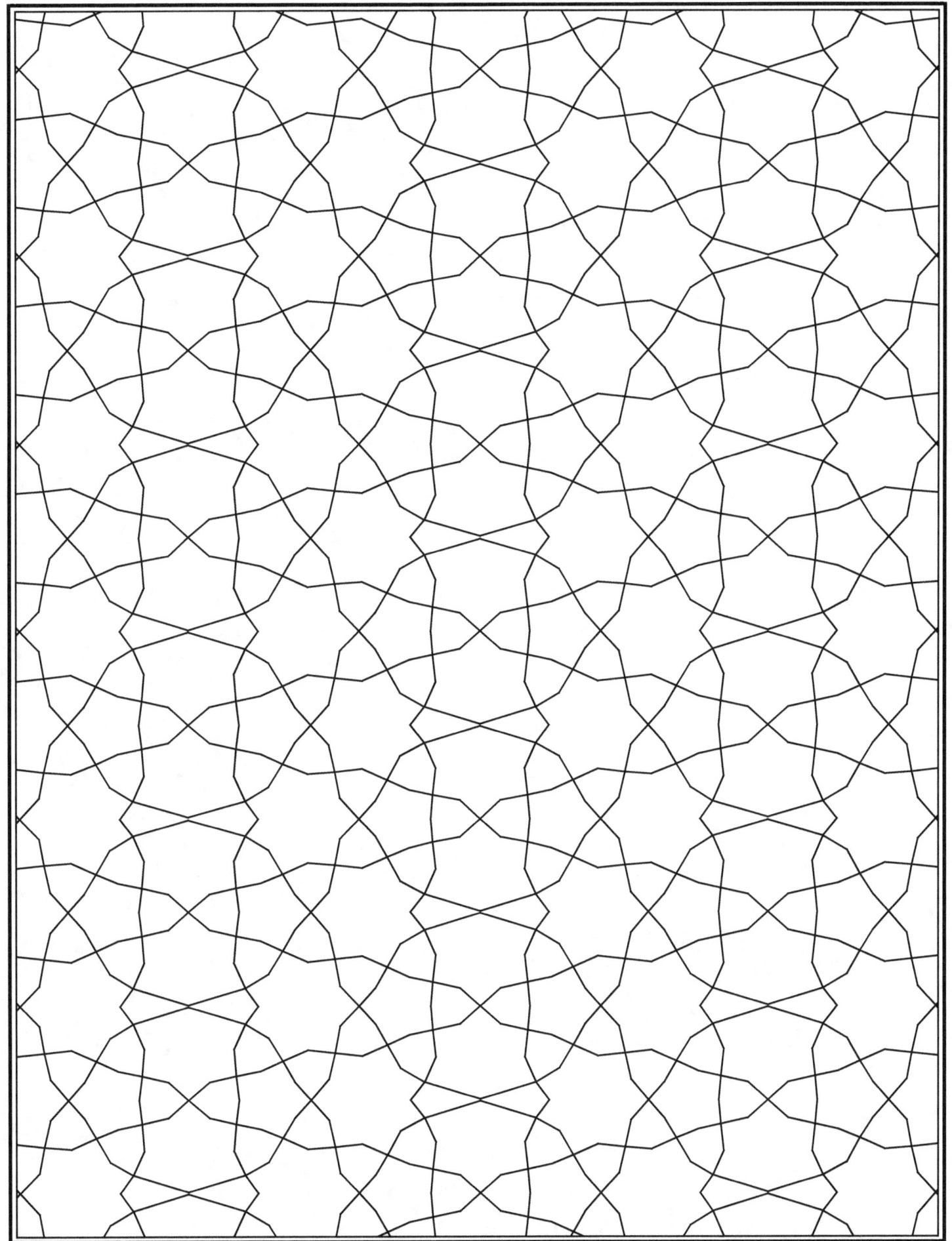

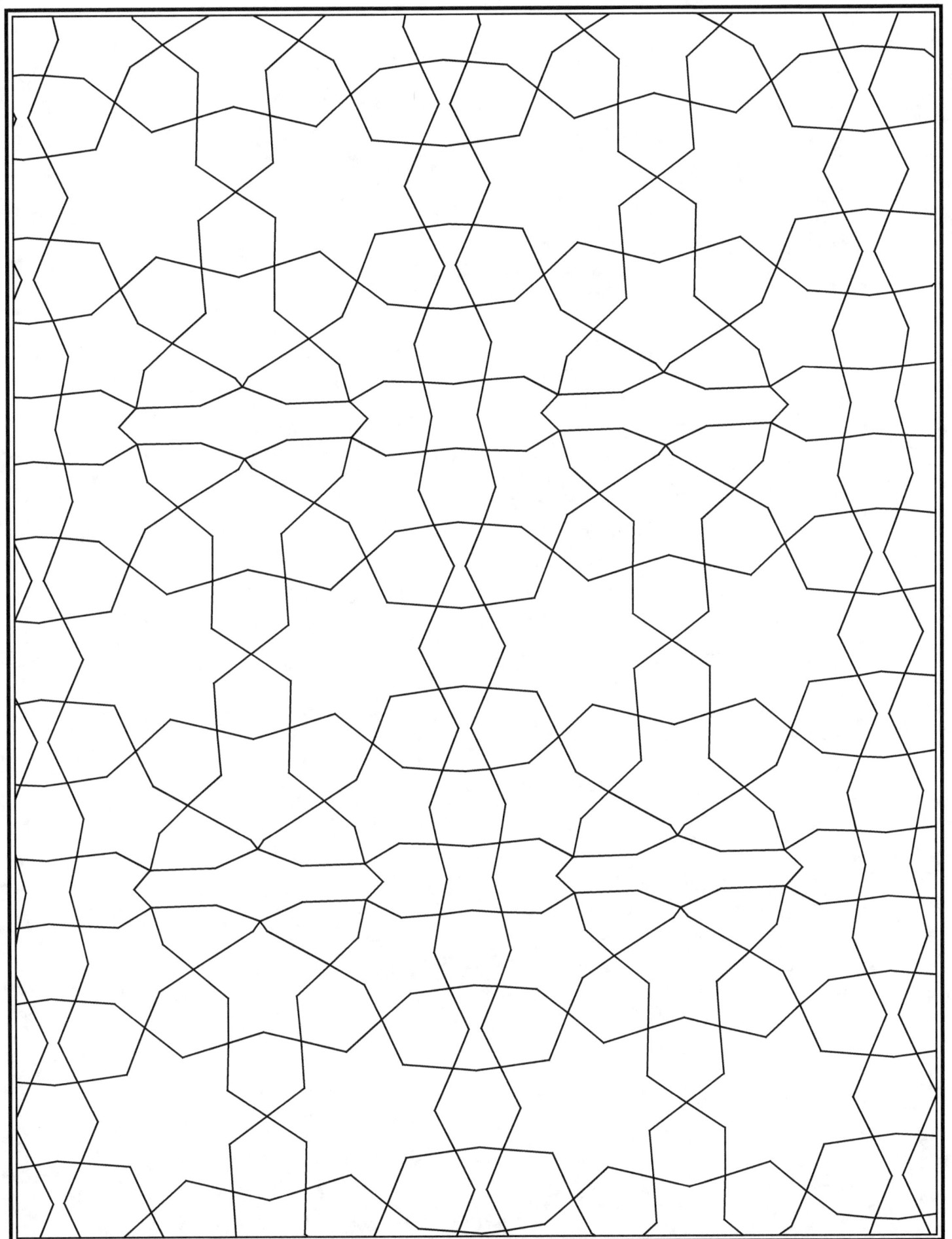

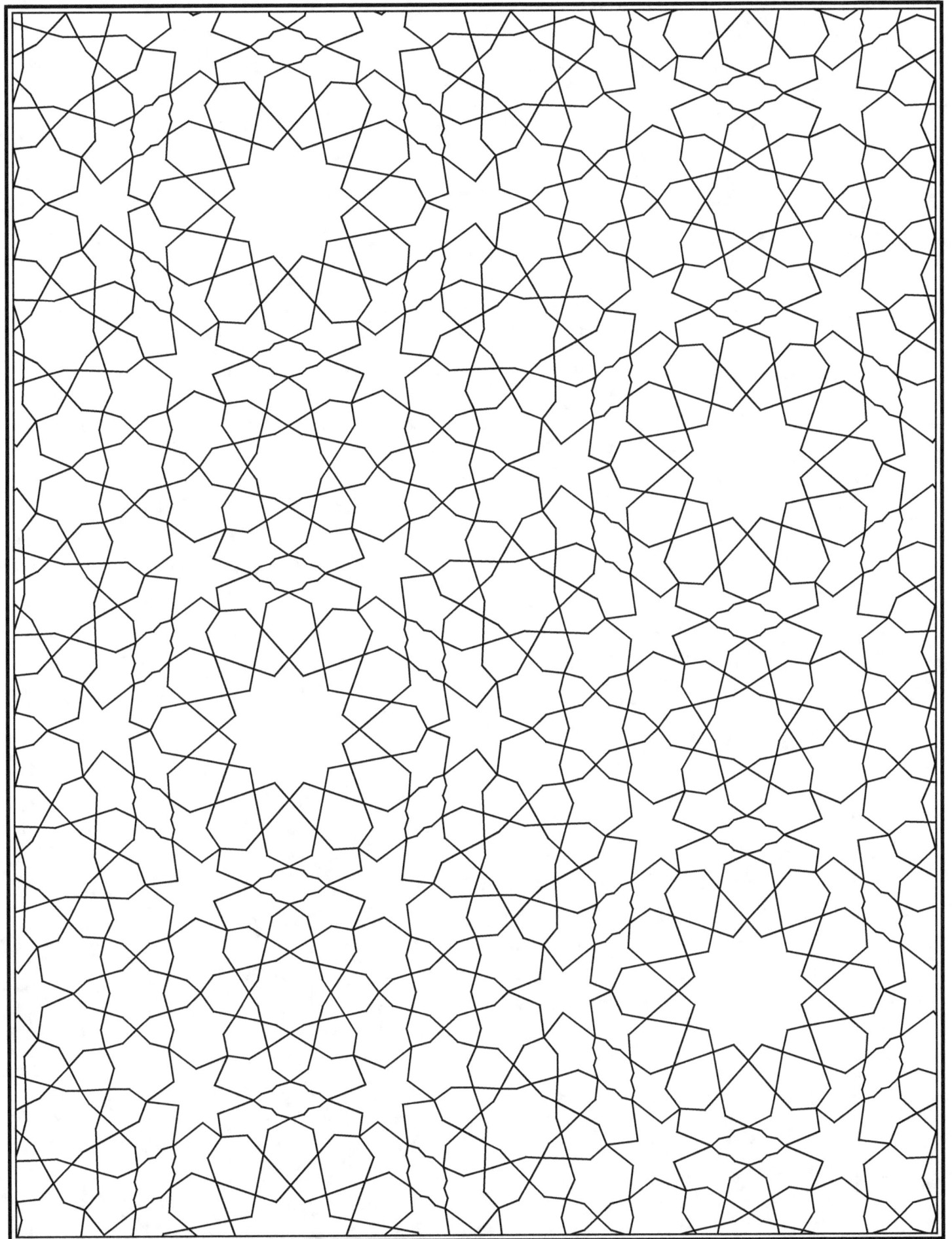

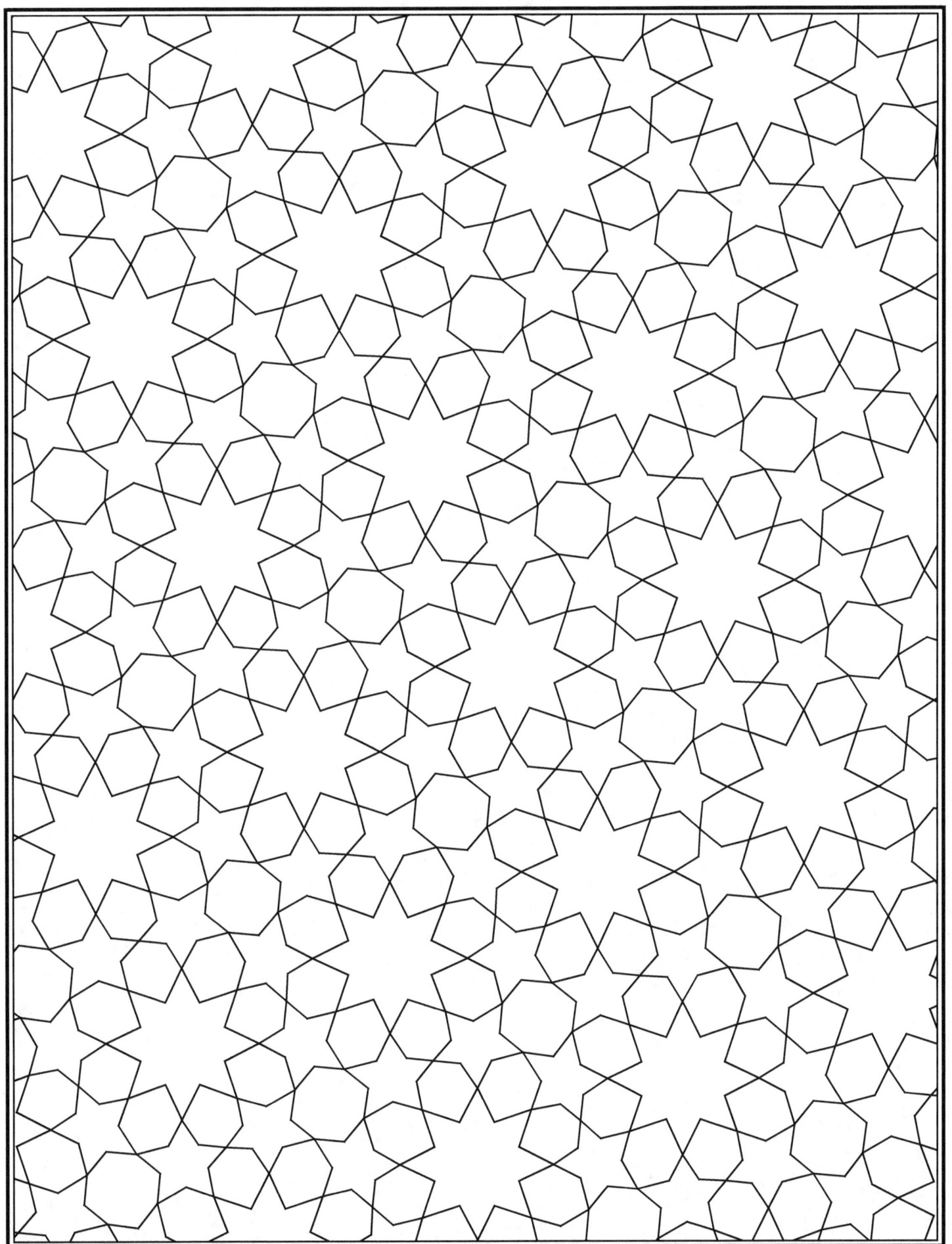

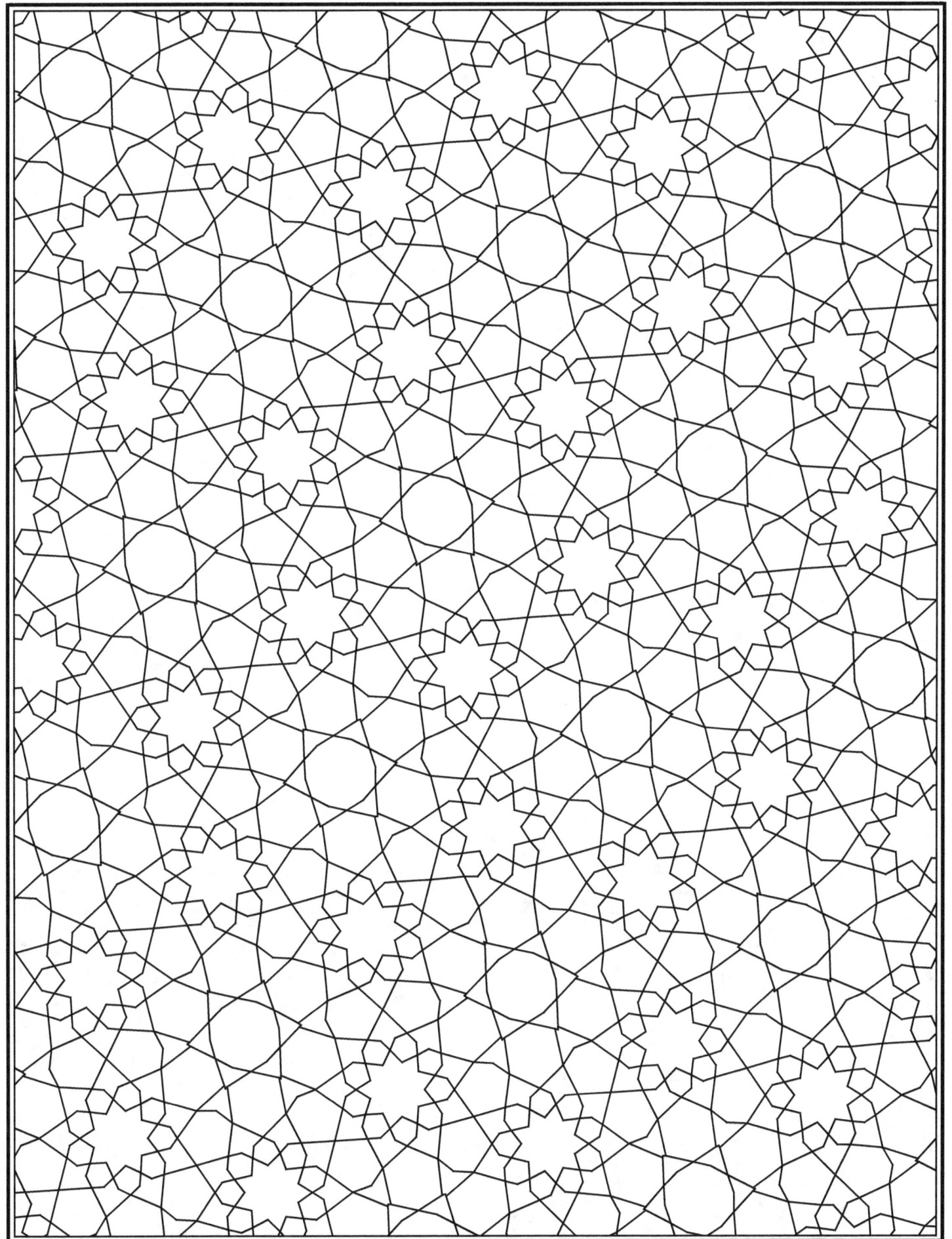

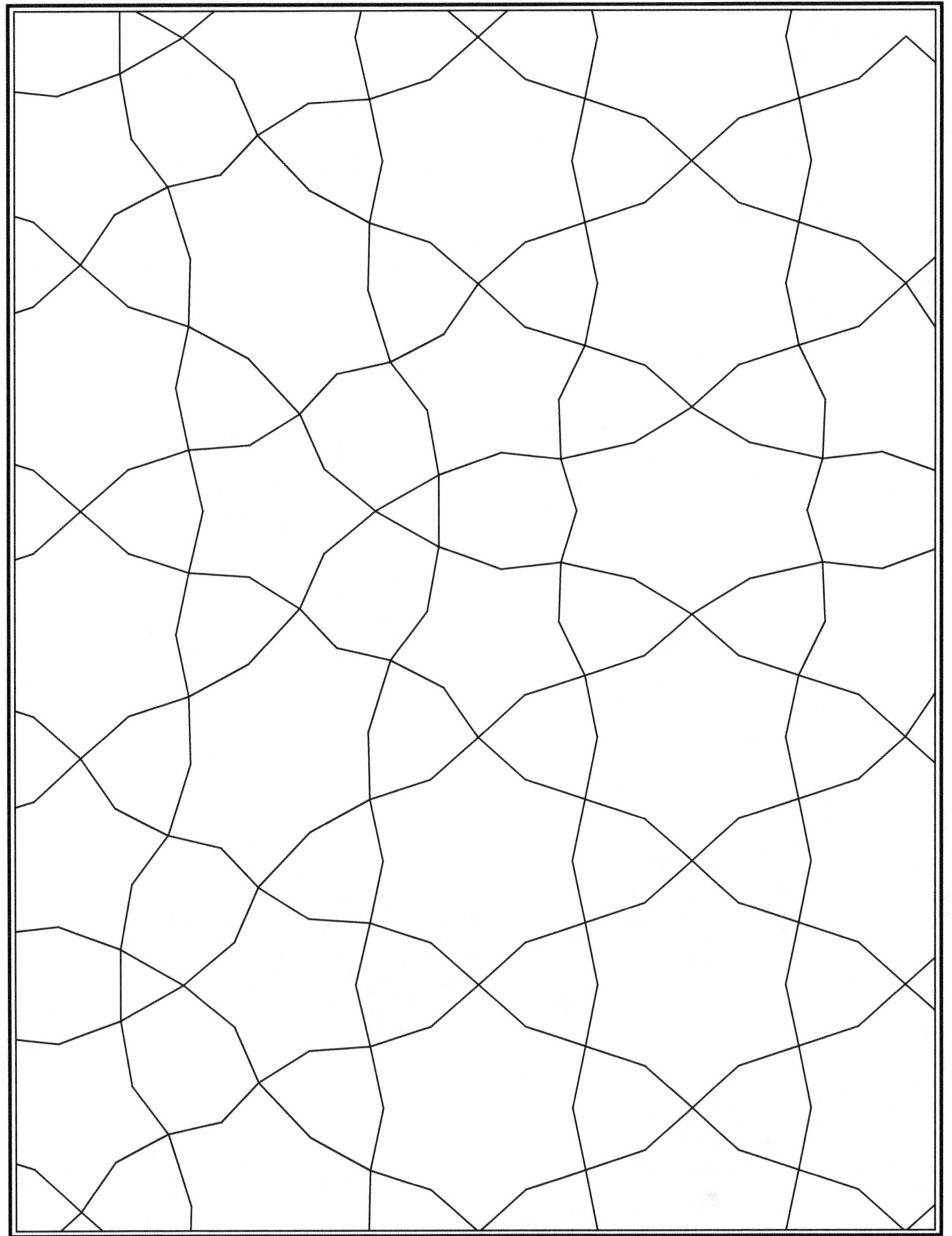

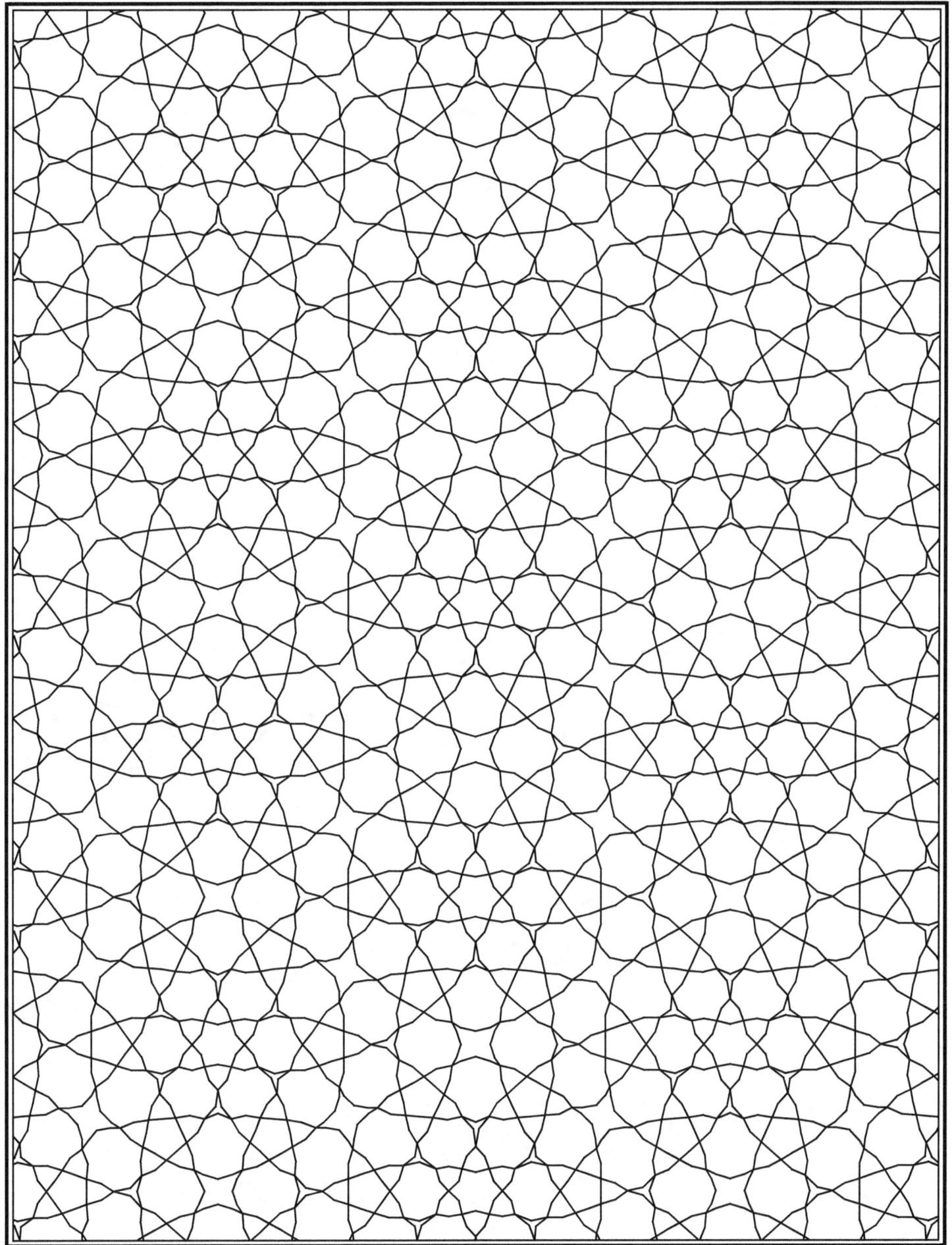

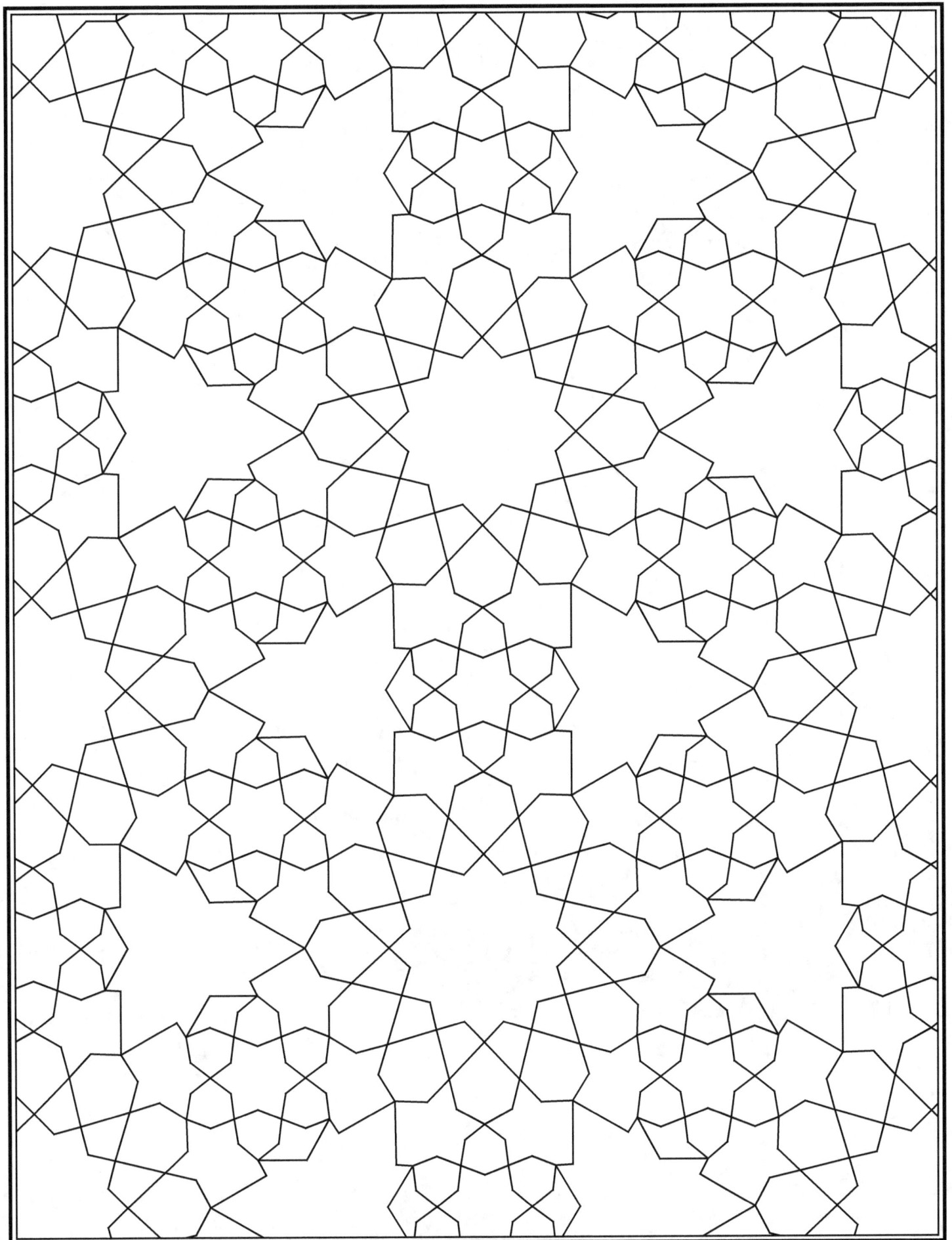

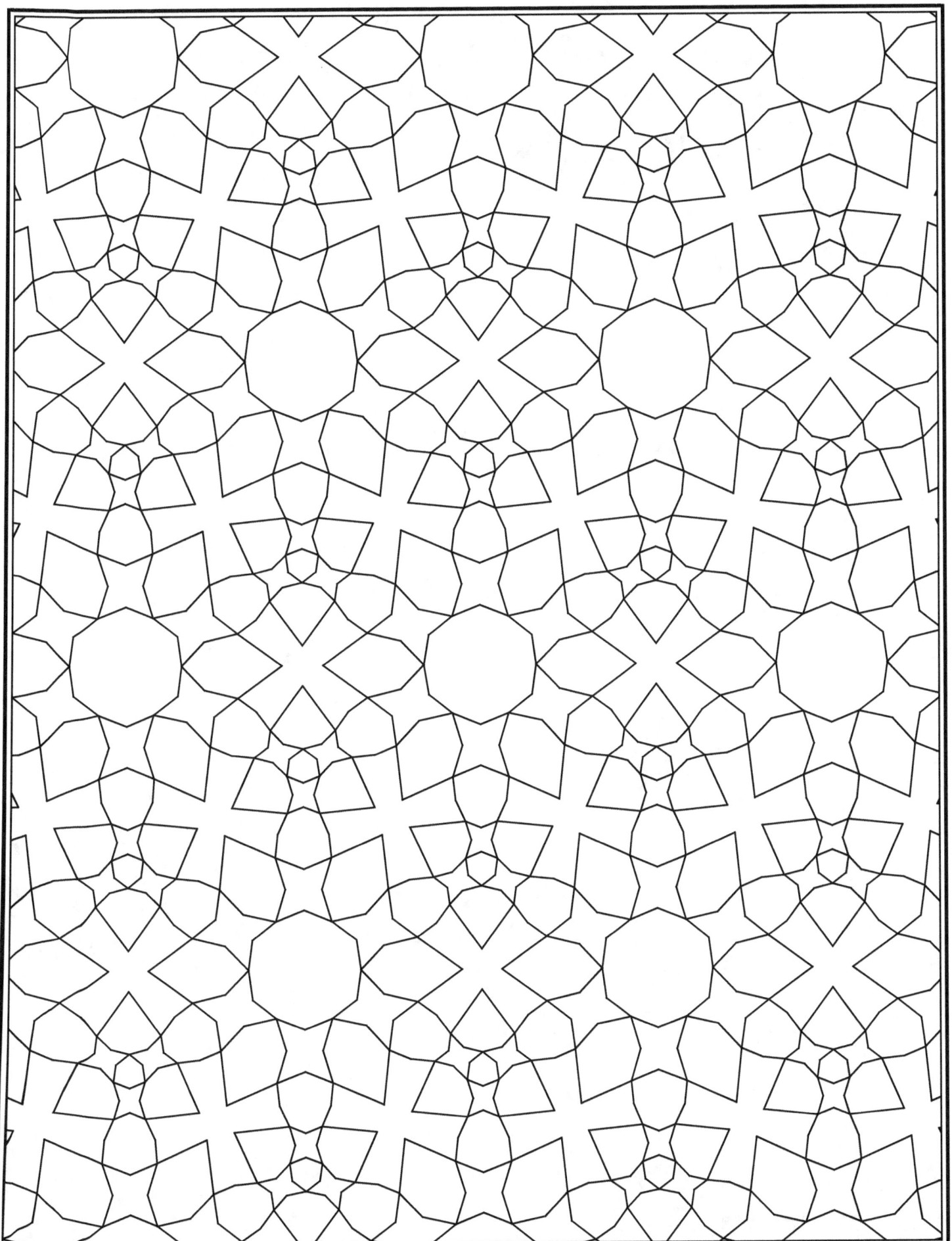